IMAGES
of America

YPSILANTI

IN THE 20TH CENTURY

D0862925

16

Cover: The railroad has played a major role in the history of Ypsilanti since 1838, when the first train arrived. The railroad connected Ypsilanti with the rest of the world, brought visitors, and transported goods to market. Here a train is being loaded with freight to be taken to some distant place for sale. Although the depot still stands, the train no longer stops in Ypsilanti. That is now a part of memory. Someday, perhaps one day soon, the train will once again stop at Ypsilanti.

IMAGES
of America

YPSILANTI

IN THE 20TH CENTURY

James Thomas Mann

ARCADIA

Published by Arcadia Publishing,
an imprint of Tempus Publishing, Inc.
Charleston SC, Chicago, Portsmouth NH,
San Francisco

Printed in Great Britain.

Library of Congress Catalog Card Number: 2003108864

For all general information contact Arcadia Publishing at:
Telephone 843-853-2070
Fax 843-853-0044
E-Mail sales@arcadiapublishing.com
For customer service and orders:
Toll-Free 1-888-313-2665

Visit us on the internet at http://www.arcadiapublishing.com

CONTENTS

INTRODUCTION

History is the foundation on which we build the future. What we are today is because of what happened in the past. Ypsilanti is the city it is today because of what has happened in the years gone by. Founded in 1823 as Woodruff's Grove, as a small farming community, Ypsilanti grew into a center of education and business by the end of the 19th century.

Over the course of the 20th century, Ypsilanti continued to grow and change with the times. The horse and the interurban were replaced by the automobile, and more change came as technology advanced. The winds of change were felt in the political matters of the city as well, as women got the vote and used it. Change would come again, as a result of the Civil Rights movement and student protest. Each has had a lasting effect on the community.

The greatest and most rapid changes came as a result of World War II, the effects of which are still felt today. Out of a farm field east of the city, Ford built a plant for the manufacture of B-24 Liberator bombers. To build the bombers, Ford had to bring in workers from other parts of the country. It was said that there were more natives of Harman County, Kentucky, living in Ypsilanti than there were in Harman County, Kentucky. Almost overnight, Ypsilanti went from being a sleepy college town to a blue collar factory town. Movie theaters and restaurants were filled with people at all hours of the day and night. There was tension between the native residents and those who came to work in the plant, as neither side understood the other.

After the war ended, some residents such as Kaiser-Frazer and Preston Tucker saw opportunity in the auto industry. Their stories ended in disappointment, as things did not work out as they had planned. They are still subject of discussion among those who remember the time.

The Michigan State Normal College became Eastern Michigan University during the 20th century. Starting out as a small teachers' college, it is now a major university with an international reputation for high standards. The best teachers, it is said, come from Eastern.

Ypsilanti is still the home of interesting people and the setting for colorful events. It has always been a great place to live, and will continue to be one long into the future.

I wish to express my gratitude to those who helped me to tell the story of Ypsilanti in the 20th century. I could not have done this without the help of Rosina Tammany and Maria Avis of the Archives of Eastern Michigan University, who spent long hours on this project. I am also grateful for the help I received from Gerry Pety, of the Ypsilanti Historical Society, and his son Marc, who went far beyond the call of duty.

All photographs appear courtesy of the Ypsilanti Historical Society, unless otherwise noted.

One
THE 1900s

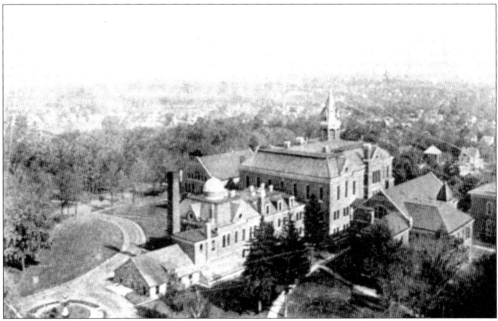

This is a view of the campus of the Michigan State Normal College, now Eastern Michigan University, as seen from the Water Tower in 1903. When the college opened in the 1850s, it had a single small building, but by the start of the 20th century, it had grown into a major center of education. The city of Ypsilanti had changed over the years as well, going from a farm community into a center of commerce and industry. The 20th century would see many changes in both the college and the city. (Photo courtesy of Eastern Michigan University Archives.)

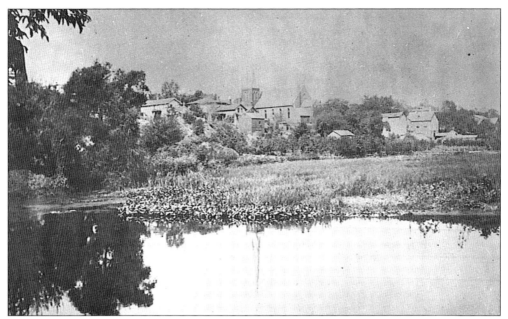

Looking north from the Congress Street Bridge in about 1900, the tall spire of St. Luke's Episcopal Church can be seen at the center of the picture.

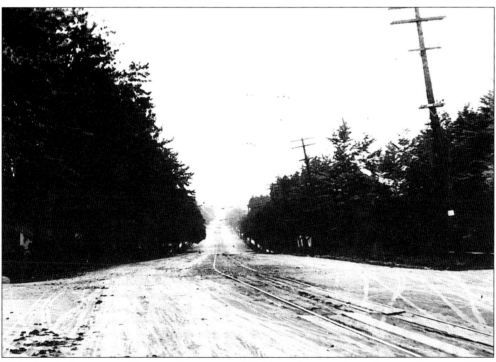

This view looks west on Congress Street, now Michigan Avenue, from Prospect Street *c.* 1900. Note the interurban tracks in the middle of the road. The view has changed since then.

This is the Hay & Todd Woolen Mill on North Huron Street as it appeared c. 1900. The building was better known as the Underwear Factory, because the product of the mill was full body union suits. The product was so popular that in some parts of the country full body union suits were called Ypsilantis.

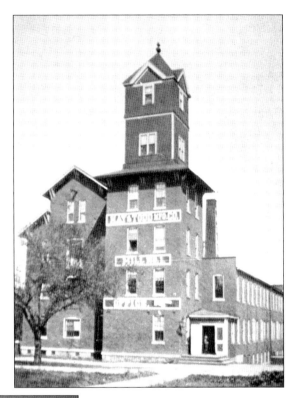

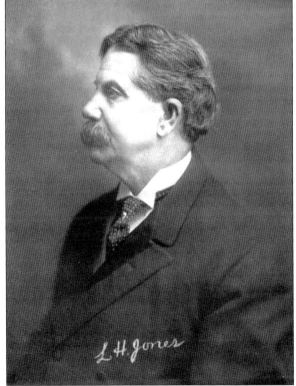

Lewis Jones was the first president of the Michigan State Normal College in the 20th century. During the ten years as president (1902–1912), the college experienced rapid increases in enrollment, and expanded its curricular offerings. (Photo courtesy of Eastern Michigan University Archives.)

11

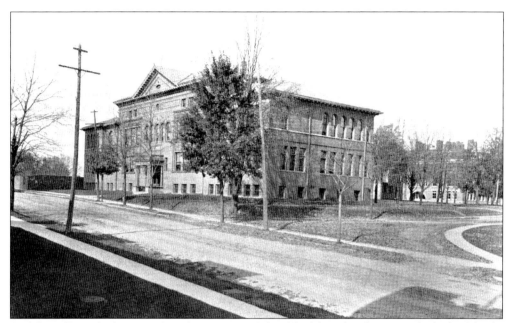

Welch Hall was built in 1896 as the Training School building, but because of a lack of funds, only the center portion was built. It was called the Training School because it was where the student teachers learned their trade. The building housed elementary and high school grade classes. The east and west wings of the Training School building were added in 1900. (Photo courtesy of Eastern Michigan University Archives.)

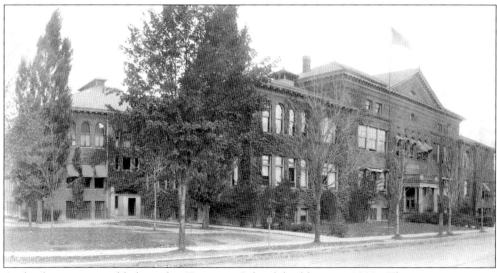

A third wing was added to the Training School building in 1909. This new wing was designed by E.M. Arnold of Battle Creek, and had overtones of the Prairie School style. The wing was demolished in 1974.

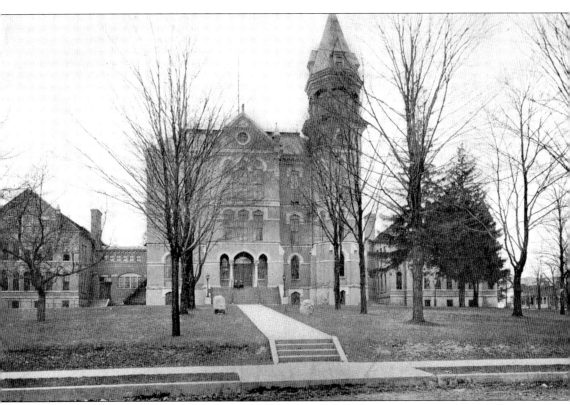

Here is the Main Building of the Michigan State Normal College as it appeared in 1909. At left is the south wing which housed study halls. In the center is the main part of the building which housed the administration offices, class rooms, and, on the third floor, the chapel. At right is the north wing which housed the library. At the far right, just visible through the trees, is the President's Residence. (Photo courtesy of Eastern Michigan University Archives.)

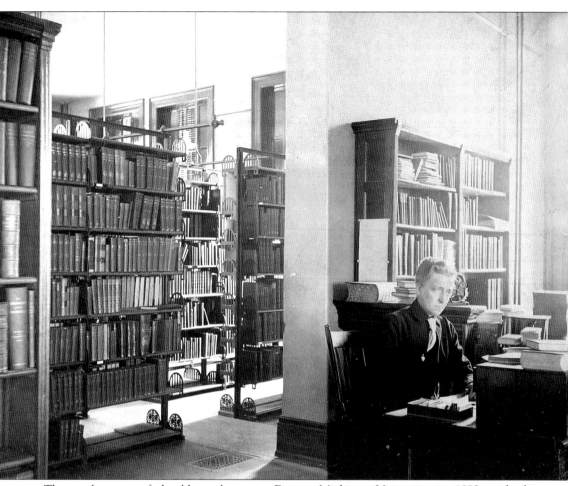

The modern age of the library began at Eastern Michigan University in 1882, with the appointment of Genevieve Walton (1857–1932) as librarian. Miss Walton remained as head of the library for the next 40 years. She was a major advocate of the improvement and expansion of the library. Miss Walton could be an imposing, even frightening presence. Yet she loved the students, and felt a great commitment to meet their needs. Sometimes, on cold winter nights, she would arrive at the library and prepare and serve coffee to the students before sending them home. (Photo courtesy of Eastern Michigan University Archives.)

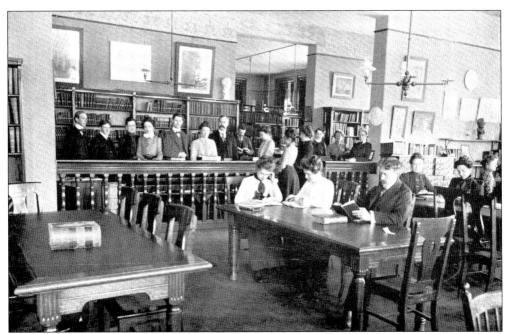

The Normal Library occupied the first floor of the north wing of the Normal Main Building from 1887 to 1930. This photograph shows the library as it appeared in 1902. Genevieve Walton is seated at the right, next to the dividing wall. (Photo courtesy of Eastern Michigan University Archives.)

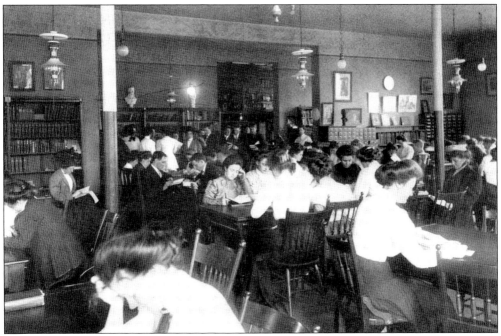

The library reading room was 40 by 56 feet, and had chairs for 150 readers. It was made attractive with reproductions of works of art and casts of masterpieces of sculpture. Still, it was a place for students to study. (Photo courtesy of Eastern Michigan University Archives.)

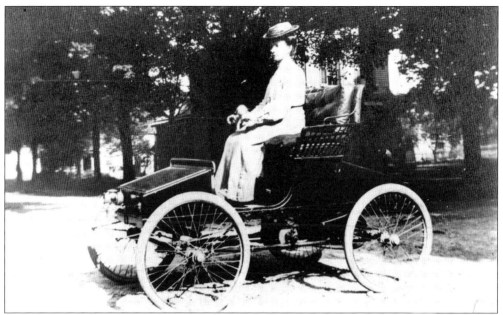

Gertrude Woodard (1870–1966) was the first licensed woman driver in Washtenaw County. She was appointed Assistant Law Librarian at the University of Michigan Law School in 1901, and that same year purchased a Covert Motorette, and even traveled to the factory at Lockport, New York, to learn how to drive it. Every day she drove from her home on Grove Street in Ypsilanti to the Law School in Ann Arbor and then back again. She gave up driving in 1911, when the students were allowed to drive. She never had an accident.

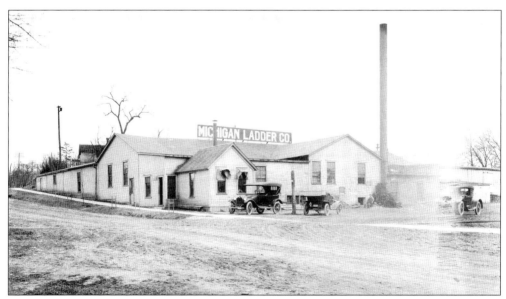

Ground for the Michigan Ladder Company building at 12 East Forest was broken in 1901, the same year the company was founded. The land on which the factory stands was donated by the city, on the condition that at least ten men are employed by the company for three years. At the end of the three years, the land became the property of the company. The company celebrated its centennial in 2001, and still occupies the same building today.

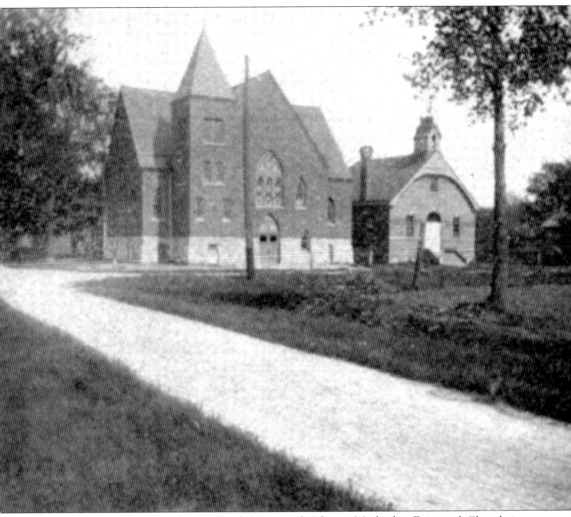

In 1843, Ypsilanti became the home of the second African Methodist Episcopal Church in Michigan, when meetings were held at first in the home of Sylus Jones, an escaped slave. The church acquired the property on the corner of Buffalo and Adams in 1856, and refurbished the small structure there. Work on a new church began in 1901, with most of the construction done by members of the congregation to keep costs down. The new church was formally opened with appropriate services on Sunday, August 28, 1904. The church served the A.M.E. community well for 95 years, until it became too small to meet the needs of the congregation. The community moved to a new church in 1999, but the old building still stands and remains in use. (Photo courtesy of Eastern Michigan University Archives.)

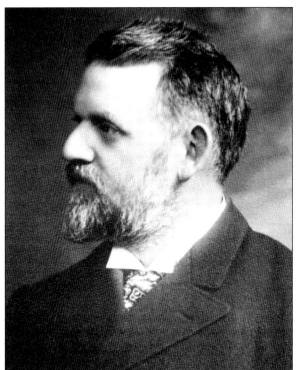

Dr. William H. Sherzer (1860–1932) was a lifelong student who found pleasure in every lesson. Dr. Sherzer joined the faculty of the Michigan State Normal College in 1892, and became head of the Natural Science Department in 1895 when Lucy Osband retired. As a scientist, Sherzer had a national reputation in geology and anthropology. He helped to choose the location of the Detroit-Windsor tunnel. (Photo courtesy of Eastern Michigan University Archives.)

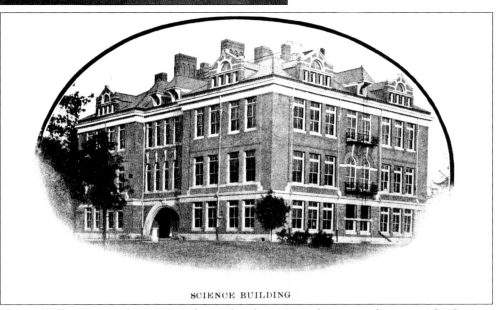

SCIENCE BUILDING

Sherzer Hall was erected in 1903 and completed in 1904, when it was known as the Science Building. When the building opened in 1903, the physics and chemistry departments were located in the east side of the building and the natural science department was in the west side. Interesting features of the original building were the narrow private stairways that linked the professors' offices to the classrooms below. The name of the building was changed in 1958, in honor of William Sherzer, who had played a major role in its design. (Photo courtesy of Eastern Michigan University Archives.)

This view of the rear of Sherzer Hall, then the Science Building, shows part of the Science Garden which was behind it. This picture shows the fountain, and the bench encircling a tree. When the tree outgrew the bench, the bench broke in two. (Photo courtesy of Eastern Michigan University Archives.)

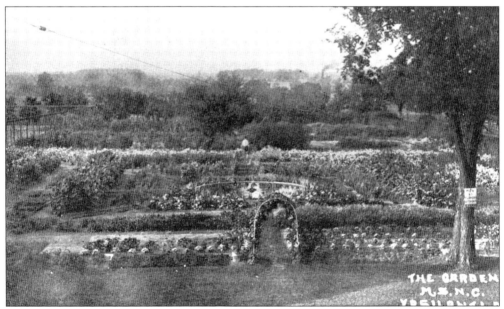

A little-known beauty spot of Ypsilanti was the Science Garden of the Michigan State Normal College, located on the north side of the Science Building (Sherzer). The primary function of the garden was to provide students with a laboratory where they could gain experience and collect specimens. Every summer the garden was divided into sections, each section the responsibility of a student of botany, horticulture, or agriculture. (Photo courtesy of Eastern Michigan University Archives.)

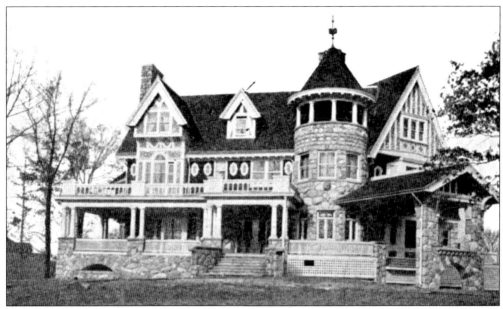

Shelly Byron Hutchinson was the local boy who made good. At first, he was known as a dance master, but while working as a clerk at a store in Battle Creek he came up with the idea of trading stamps. Hutchinson was the "H" in S and H Green Stamps. He returned home to build a splendid mansion at Forest and River in 1904. Soon after, he lost his money, his young wife, and his home. The house still stands, and is now the office of the High Scope Foundation. (Photo courtesy of Eastern Michigan University Archives.)

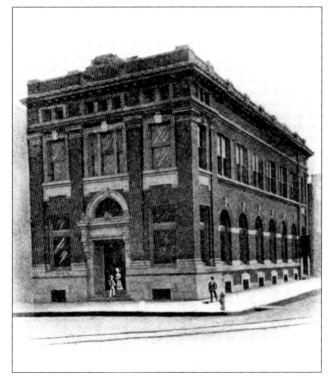

The First National Bank of Ypsilanti opened the doors of its new building at 133 West Michigan Avenue on the morning of Monday, April 24, 1905. The First National Bank of Ypsilanti was incorporated on November 25, 1863, and had the distinction of being the oldest national bank in the state of Michigan. The building was remodeled and modernized several times over the years. It was recently renovated again, and now enjoys some of its former glory. (Photo courtesy of Eastern Michigan University Archives.)

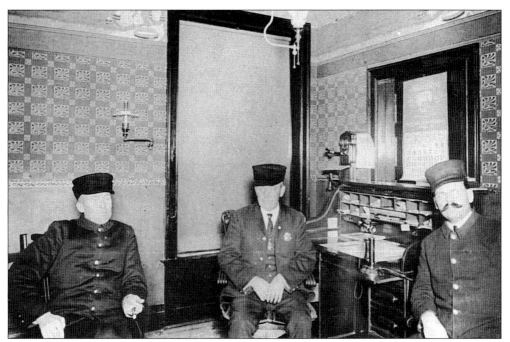

In 1905, the Ypsilanti City Police Department had its office on the second floor of the Ypsilanti Savings Bank Building. Pictured here are, from left to right, Thomas Ryan, Chief of Police Milo Gage, and Walt Pierce. The Savings Bank building is now City Hall.

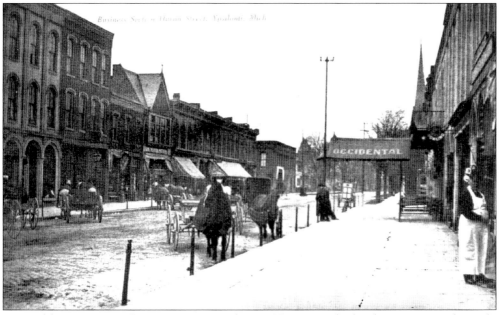

Pictured here is Huron Street as it appeared in 1907. Notice the hitching posts on the curb, where the horses could be tied as the farmer or housewife ran their errands. The hitching posts are long gone, and some of the buildings across the street were removed in the 1950s to make room for a parking lot.

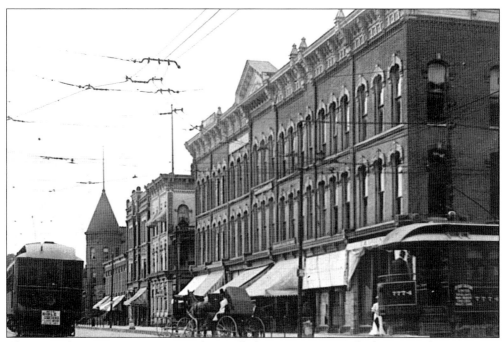

This is Michigan Avenue in 1907, then called Congress Street, looking east from just east of Washington Street. The Union Block is to the right, with Cleary College just visible in the distance.

The Ypsilanti Hay Press Company came to the city in 1907 and opened the largest factory in the world devoted exclusively to the manufacture of hay presses. The factory was on the north side of Forest, just east of the Huron River.

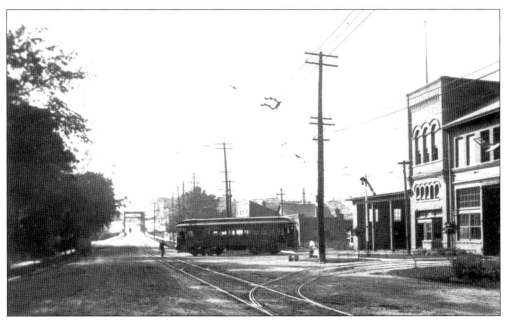

An interurban car in front of the car barns and power house on East Michigan Avenue, just east of the Huron River. The interurban made life easier and travel faster, as people could go from one place to another in less time than by horse and buggy. Early in the 20th century, one could travel almost anywhere in the state of Michigan by interurban.

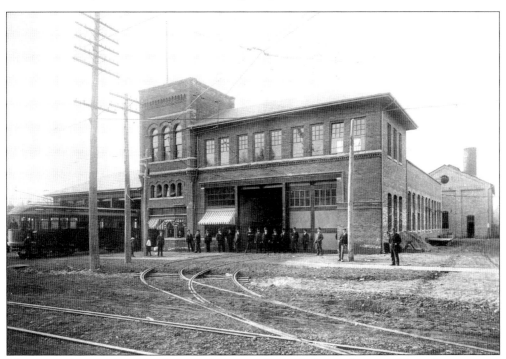

The interurban car barns and power house on East Michigan Avenue. Here the cars were serviced and, when necessary, rebuilt. The building was used by the interurban companies and the ownership changed several times over the years, until the last interurban run in 1928.

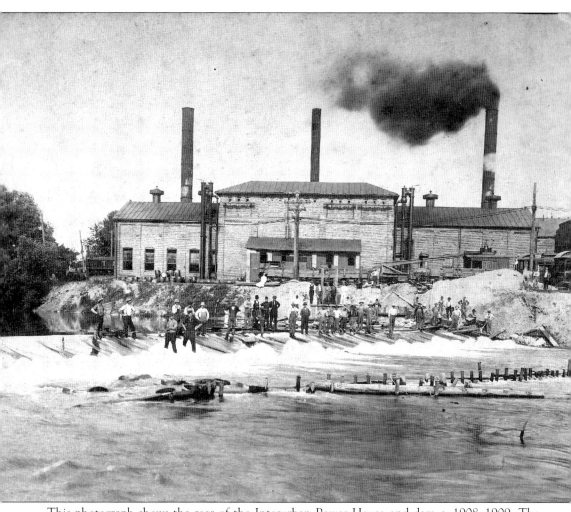

This photograph shows the rear of the Interurban Power House and dam *c.* 1908–1909. The occasion for the photograph is not known.

The Shaefer Hardware Store was at 23 North Huron when this picture was taken *c.* 1908–1909. Here the home owner or family handyman could find everything he needed, for any project his wife had told him she wanted to get done.

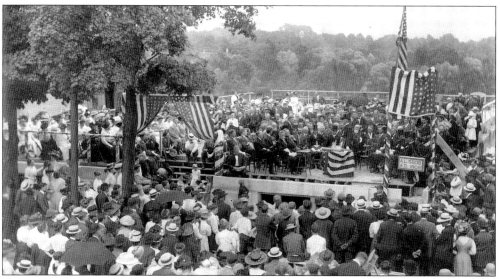

The cornerstone of the Masonic Temple at 76 North Huron Street was laid on July 22, 1909, with the accompanying ritual of the Masonic orders. As part of the ritual, according to *The Daily Ypsilanti Press*, a number of items were enclosed in the cornerstone, including: bylaws of the lodge, chapter and council, articles of incorporation, a Confederate $100 bill, a Masonic penny, the architects Osgood & Osgood, the contractors, Cole Brothers, and the superintendent, J.H. Woodman. Exactly how the architects, contractors, and superintendent were enclosed is unclear. Presumably, it could have been done by careful folding.

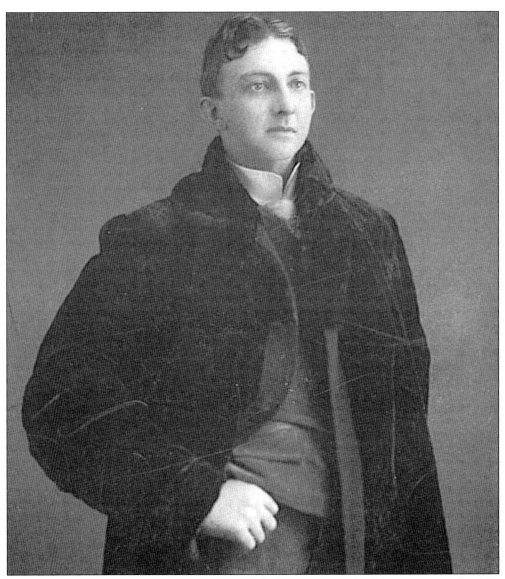

Warren Lewis was an extraordinary auctioneer of whom it was said, if there were anything he had not auctioned, a new edition of the dictionary would have to be printed to include it. Lewis is still remembered today for his operation of the Lewis Horse Exchange from 1900 to 1911. This was not a place to exchange horses, but a place to play the ponies. The Exchange was a gambling den. Every day during the racing season, gamblers took the train from Detroit to Ypsilanti, and placed their bets at the Exchange. Telegraph lines into the building kept them informed on the results of races from across the country. At first Lewis operated the exchange from a building on East Congress Street, now Michigan Avenue, then later moved it to what is now called Depot Town. Lewis managed the Exchange at 54 East Cross Street from 1905 until he was forced to close it in 1911.

Two
THE 1910s

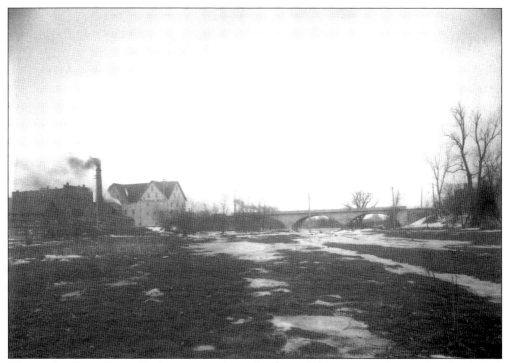

This is the Cross Street Bridge as seen from the flats of the river on the north side. At left are the Follett House and the Deubal Flower Mill. Cross Street Bridge was built in 1910. This photograph was taken soon after, as the World War I memorial tablets, added in 1919, are not visible on the bridge.

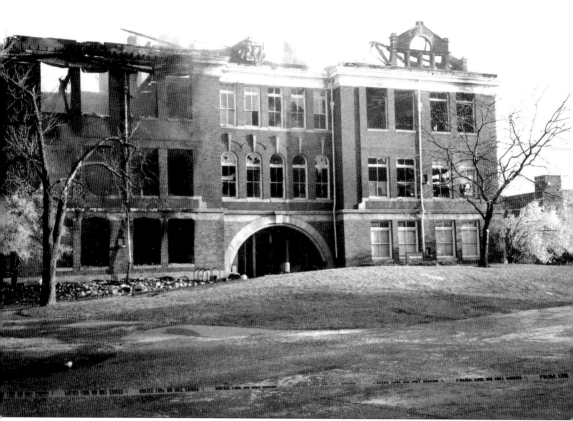

The upper floors of the Michigan Central Railroad Depot at Ypsilanti, with its tall tower, were destroyed by fire in May of 1910. The railroad, to the disappointment of the community, chose not to build a new depot, but to repair the ground floor of the old one and add a new tower to that. Today, the ground floor is all that remains of what was once the most beautiful depot between Detroit and Chicago.

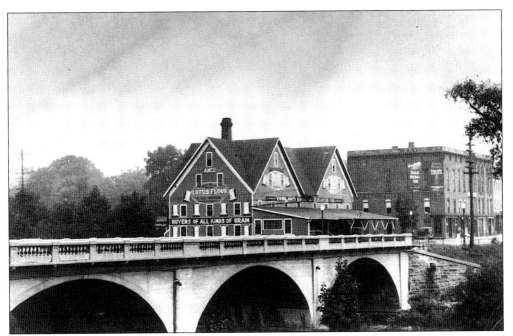

East Cross Street Bridge is pictured as it appeared in 1912–1914. The building at the center of the picture was the old mill, which was demolished in 1925. The mill was replaced by an automobile garage. The building still stands, but is now home to Me N My Sister's Country Store and The Teacher Shop.

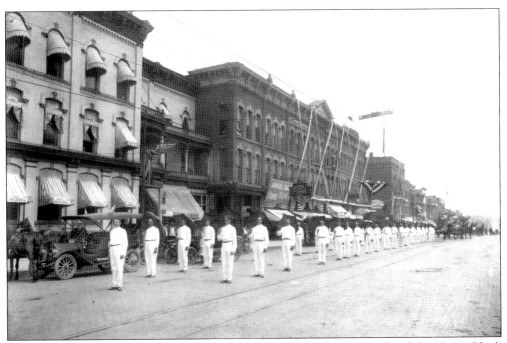

An early 20th century parade stops in front of the Hawkins House Hotel and the Union Block on Michigan Avenue. Just visible in the distance is the Clapp & Jones steam fire engine. The old fire engine was replaced with a motorized one in 1916.

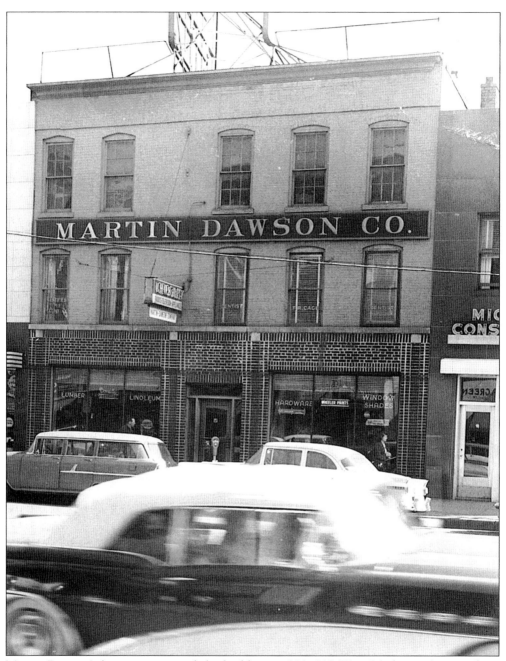

Martin Dawson's business occupied the building at 211–213 West Michigan Avenue from 1897 until 1963. Dawson initially sold farm implements and later went into the feed business. After his death in 1915, Dawson's family took over the business, and it just barely survived the Great Depression. The family stopped selling grain, seed, and feed and went into the sale of paint, wallpaper, hardware, and lumber. The business survived for nearly 70 years because it changed with the times.

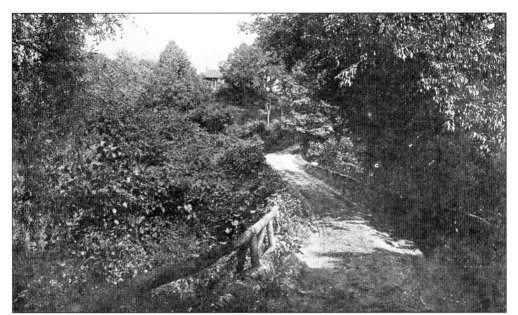

Pictured here is Riverbrink during summer. Normal College President Lewis Jones purchased property on the north side of the Huron River and east of LeForge Road in 1911, the year before his retirement. Here, on a high bank overlooking the river, he built a summer cottage. He used natural field stone found on the property to build a fireplace. From here he could enjoy the restful vistas of the winding paths and the wagon road seen through the shade of oak and hickory trees. (Photo courtesy of Eastern Michigan University Archives.)

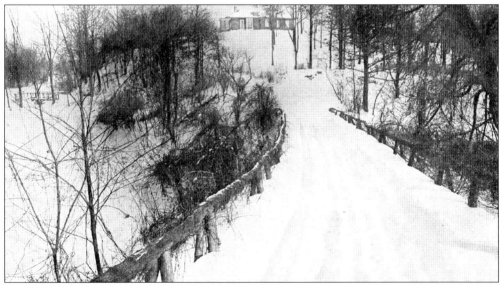

Riverbrink is seen here in winter. Jones opened his land to the public, and invited everyone to walk along its paths. This was his place for meditation and reading, but he always welcomed company. Students found strolling on the property were invited in to the cabin for a cup of tea and conversation. Riverbrink was an unofficial city park and popular place for students into the 1960s. Then development encroached the land, and now it is covered by apartment houses. (Photo courtesy of Eastern Michigan University Archives.)

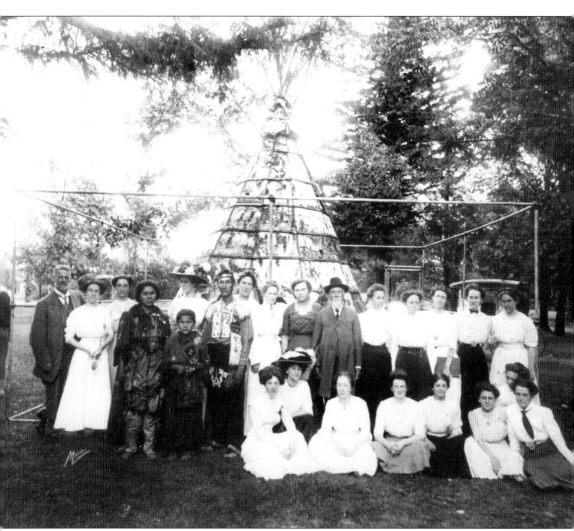

Simon Pokagon was a Pattawatomi Indian who made a birch bark wigwam that was displayed at the Chicago World's Fair of 1893. In 1911, Normal College students raised the funds to purchase the wigwam and it set up on campus. Pokagon's Wigwam was placed on the campus, just east of the Science Building, now Sherzer Hall. The location was intended to be permanent. The wigwam was removed in January of 1919 and placed in storage, because the years of exposure had taken a toll. Today, no one knows what became of the wigwam. (Photo courtesy of Eastern Michigan University Archives.)

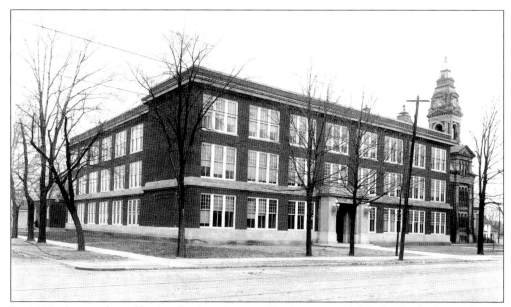

By 1911, the number of high school students in Ypsilanti passed 1,000. The high enrollment and the condition of the old Central School building made building a new high school necessary. Construction on the new building, on Cross Street, next to the old one, began in February of 1915. The work was done and the building was occupied by the beginning of 1916. The new building is now the west wing of Old Ypsi High. Just visible in the background is the Old Central School Building, which was then still in use.

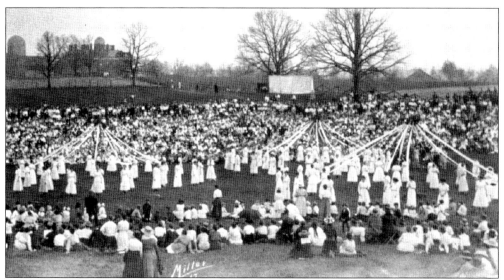

From 1911 until 1936, the arrival of spring was celebrated at the Normal College with an event called May Day on the Green, later changed to Spring Festival. Held in a natural amphitheater north of Sherzer Hall, where the ground was level, as many as 500 young women could dance around the maypole at one time. The festival may have been a victim of its own success, as each one had to surpass the one held the year before, and after 1936, no one could make the commitment in time and energy necessary to produce it. (Photo courtesy of Eastern Michigan University Archives.)

A Mr. Lee founded a brewery in Ypsilanti in 1866, which he sold to the brothers Adam and Louis Foerster in 1870. The original brewery was a frame building, and L.Z. Foerster built a large brick building on South Grove Road in 1890. The Foersters called their brew Bavarian; they also made a bock beer. The Foerster family sold the brewery to Hoch in 1914. Hoch was closed by the Volstead Act in 1917.

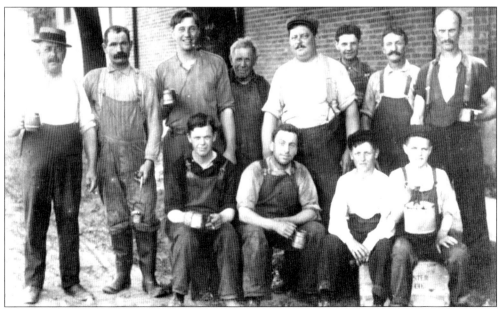

This photograph, taken c. 1912, shows ten men and two boys who were employed at the Foerster brewery. The boy at the right, Michael Sullivan, holds a large bucket of beer, as it was his job to fetch beer for the men during the day. It was then the custom for the men to drink beer whenever they pleased, and all had their little tankards with easy reach.

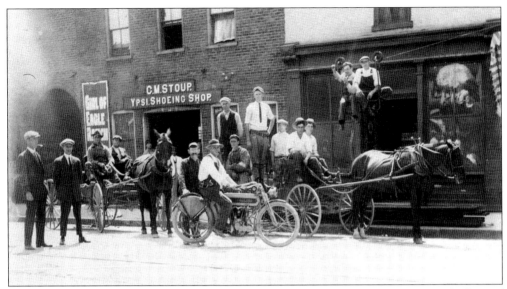

This crew was stringing telephone lines and installing telephones in the homes and offices of Ypsilanti in 1913. Although the crew relied for the most part on horse powered transportation, it had recently been "motorized" with a motorcycle when this picture was taken.

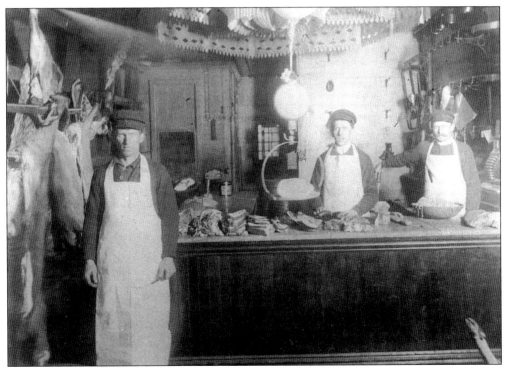

Buying fresh meat was a simple task at the start of the 20th century. You went to the market and bought it. To get fresh meat, you went to the meat market everyday, because, as there was then no real refrigeration, the only way to keep it from spoiling was to salt it. To keep the meat fresh, the animals had to be slaughtered that day. Back in 1913, the Alban & Augustus Palace Meat Market at 204 West Michigan was typical of such places. Their telephone number was 40.

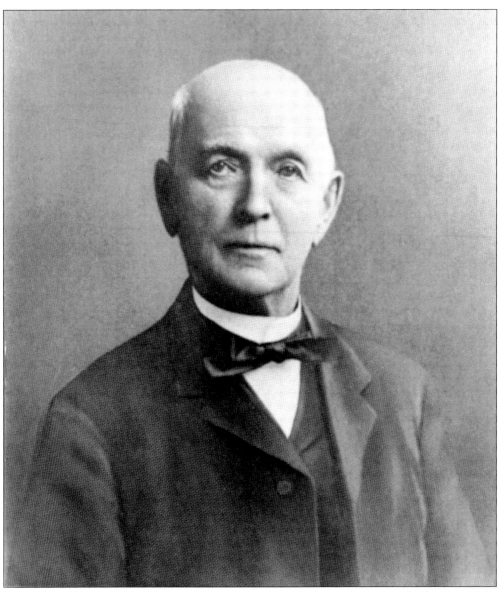

Daniel Lace Quirk (1818–1911) was born on the Isle of Man, and came to Ypsilanti in 1860. After he arrived, he was one of the men who organized the First National Bank of Ypsilanti in 1863. He was also a founder of the underwear factory, and the Peninsular Paper Co., and was a backer of the Opera House. At the time of his death at age 94, he was the oldest working banker in the state of Michigan

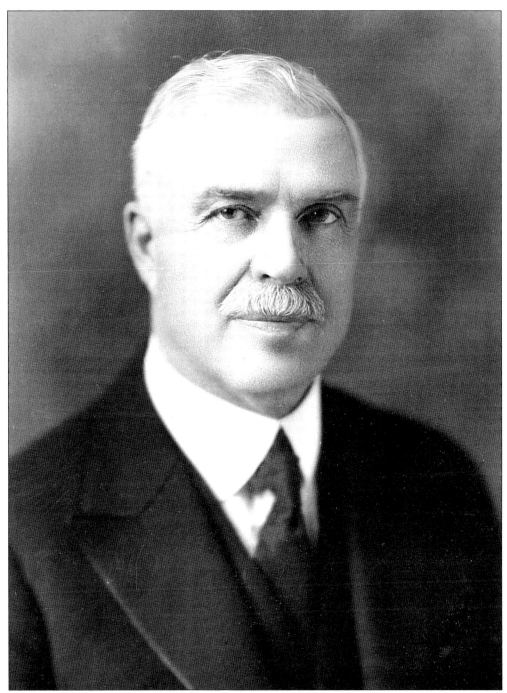

Charles McKenny looked like a college president, and was president of the Michigan State Normal College from 1912 to 1933. His had the longest term of any president at the school. During his 21 years as president, he oversaw the improvements in the physical appearance of the campus, including the construction of five new buildings. McKenny believed teachers had to be held to a high standard of morality, and expelled female students who were caught smoking on campus. (Photo courtesy of Eastern Michigan University Archives.)

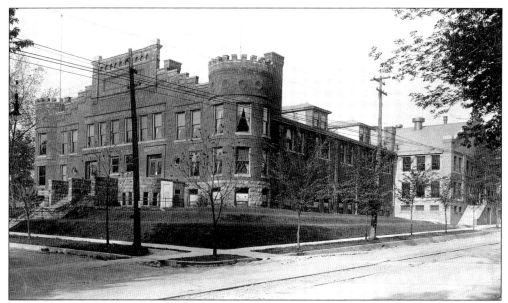

The Michigan State Legislature appropriated $35,000 in 1913 for the construction of an addition to the Normal Gymnasium. The addition was built at the west end of the building where the tennis courts had been. The addition was 66 by 120 feet and included a gymnasium, as well as a swimming pool in the basement. The addition became the boys' gym, and the original building was turned over to the girls. (Photo courtesy of Eastern Michigan University Archives.)

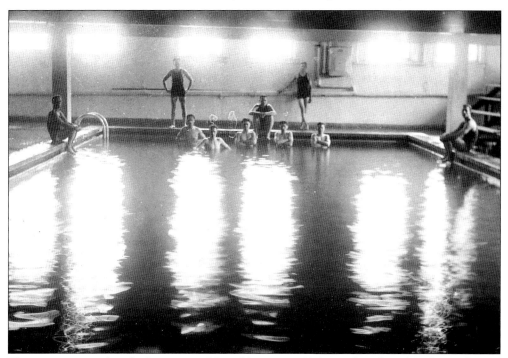

The swimming pool in the basement of the addition was 60 feet in length and 21 feet wide, and had an extreme depth of 8 feet. Another noted feature of the swimming pool was the low ceiling, on which many a diver hit his head. (Photo courtesy of Eastern Michigan University Archives.)

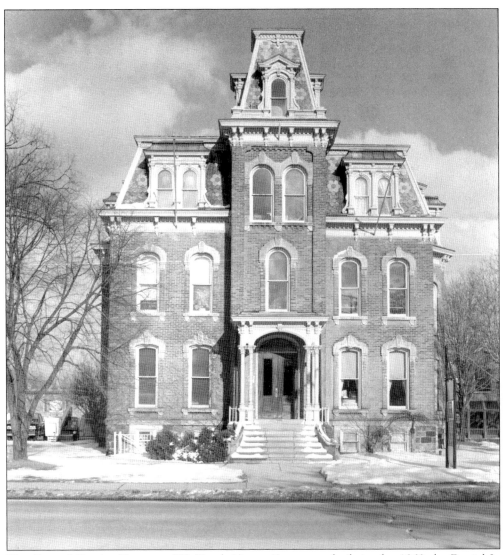

The Second Empire House at 300 North Huron Street was built in the 1860s by Daniel L. Quirk Sr., and is a fine example of the style. The children of Daniel Quirk gave the house to the city, and from 1914 to 1974 it was Ypsilanti's City Hall. Today the first three floors are used for commercial office space, with the top floors providing space for apartments.

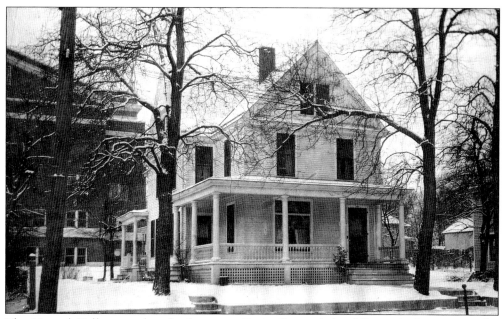

The Normal College purchased a house on Perrin Street, behind Pease Auditorium, in the spring of 1914 and turned it into the Health Cottage. The Health Cottage provided a place for sick students to stay as they recovered from whatever ailed them, including tonsillitis, colds, bilious attacks, nervous exhaustion, chronic appendicitis, and other ailments. The house remained in use as the Health Cottage until 1938, when it became the home economics practice house. The house was demolished in the 1970s in order to make room for a parking lot. (Photo courtesy of Eastern Michigan University Archives.)

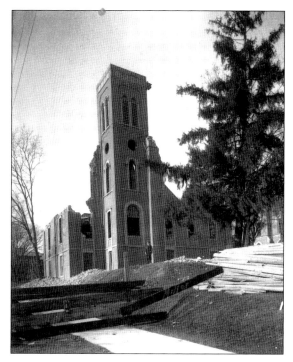

As the old Main Building of the Normal College was built section by section over a period of years, so it was demolished section by section over a period of years. The first step in the process was taken in 1915, when the south wing was removed and the Music Conservatory Building, pictured here, was razed.

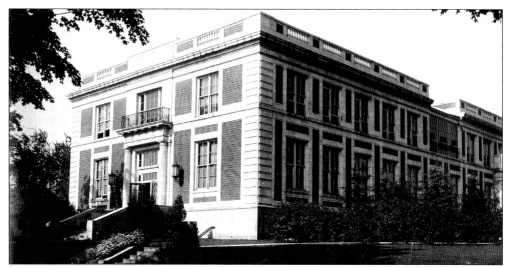

The Music Conservatory Building and the south wing were razed to make room for the new Administration Building. The building housed the administrative offices and the modern language department on the first floor. The drawing department was on the second and the manual training was in the basement. The building was called the Administration Building until 1950, when the administration offices moved into present-day Pierce Hall. The building was then named in honor of Richard G. Boone, the first true president of the college. The building was named in his honor; but because his style of administration was dictatorial, this was done long after everyone who had known him was safely dead. (Photo courtesy of Eastern Michigan University Archives.)

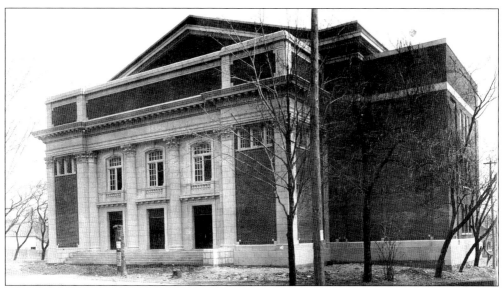

An auditorium on the campus of the Michigan State Normal College had long been the dream of Frederick H. Pease, Professor of Music from 1863 until his death in 1909. As head of the music department, Pease turned the department into one of the leading music programs in the state. He deeply felt the need for a place where his students could perform. Pease worked hard for appropriations from the state for an auditorium, but was never successful. The money would not come until after his death.

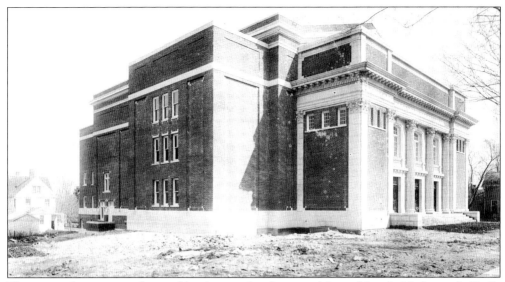

The new auditorium was designed by the noted architectural firm of Smith, Hichman & Grylls of Detroit and was built in 1915. As construction on the auditorium neared completion, the State Board of Education decided to name the new building the John D. Pierce Auditorium, after the father of public education in Michigan. Public pressure forced them to change their minds, and the building was named the Frederick H. Pease Auditorium, after the man who had done so much for the music program at the school.

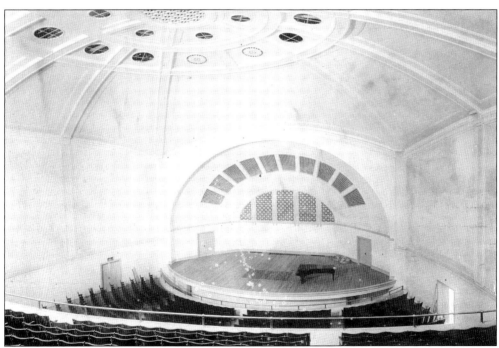

This is a view of the interior of Pease Auditorium. The stage has provided a platform for student concerts, the Detroit Symphony Orchestra, John Philip Sousa, and many others. It appears barren and empty in this photograph, because the grand organ with its 4,500 pipes was not installed until 1961.

The house at 229 West Michigan Avenue is pictured as it appeared in 1915, just before it was demolished to make room for the new U.S. Post Office building. The glory days of the house are long past. It is hard to believe that once an elaborate reception was held here by Robert McKinstry, for his friend Martin Van Buren, the President of the United States in the 1830s.

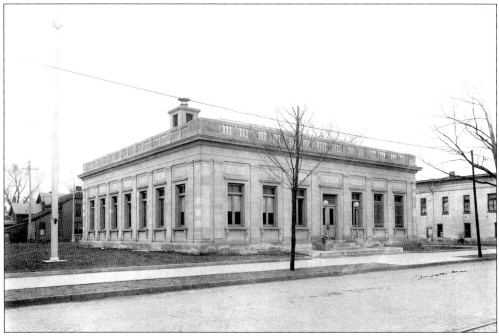

Ypsilanti was fortunate in 1915, when the federal government agreed to build a new post office in the city. Designed by the post office department in Washington D.C., it was a one-story building with a basement covering a total ground area of 5,100 feet. Although a one-story building, it was as high as a two-story building. It was covered in white stone instead of brick. It remained in use as the post office until 1963, when it was renovated at a cost of $38,813, and reopened in November of that year as the public library.

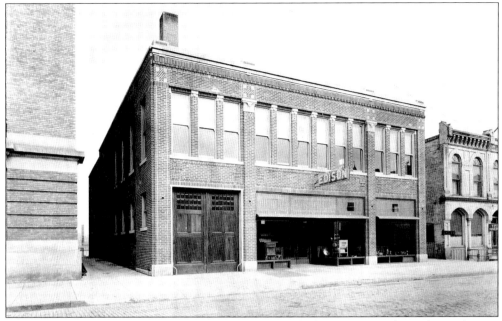

The Detroit Edison Building at 64 North Huron was built in 1916, and stands on the site where Godfroy's fur trading post had stood 100 years before the Edison Building was built. Note the wooden doors on the left side of the building.

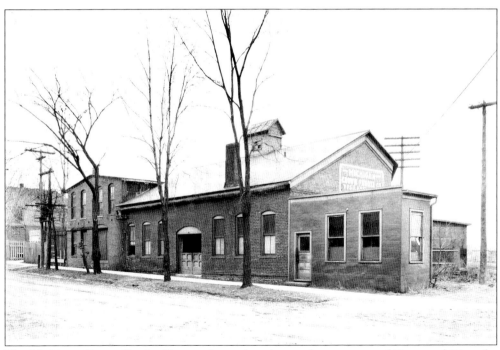

The Michigan Crown Fender Co. was located at the northeast corner of Cross and River for some time, but had moved and left the building vacant when this photograph was taken in 1916. Joseph Thompson moved his Dodge dealership here in 1917, and remained here until 1925 when he moved into a new building on Michigan Avenue in 1925.

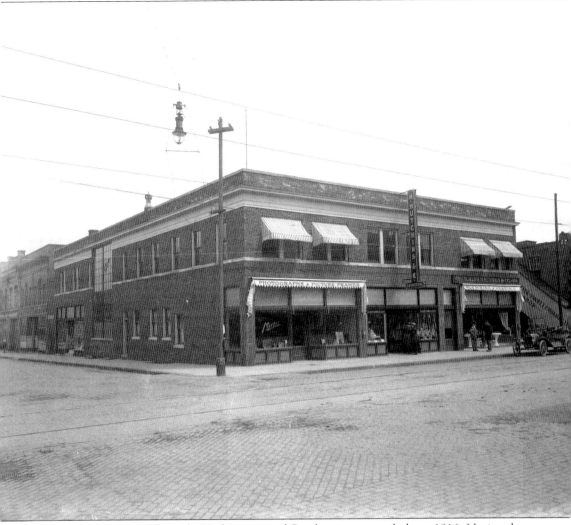

The northeast corner of North Washington and Pearl as it appeared about 1916. Notice the street is paved with brick, and the rails for the interurban run down the middle of the street.

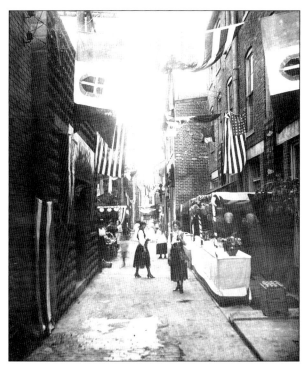

The Ypsilanti Patriotic Service League was formed during World War I, for the coordination of fund raising activities for the war charities. What was most likely the most memorable activity of the league was the Alley Festa. This was held in the alley and open space of the block bounded by Michigan Avenue, Washington, Pearl, and Huron Streets.

This usually unbeautiful area was turned into a palace of delights, with vendors, amusements, motion pictures, fortune tellers, and vaudeville shows. The first Alley Festa was held in September of 1917, and raised a total of $3,645.20.

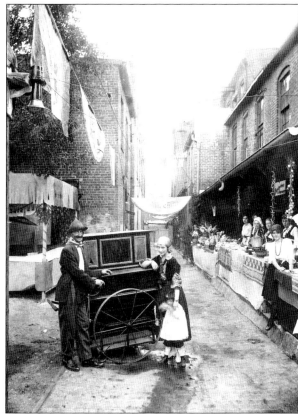

At the Alley Fests many of the most prominent members of the community could be found in the most outlandish costumes. Daniel L. Quirk, a major force behind the festival, sold statuary while dressed in bandannas and checkered shirt. He made quite an impression.

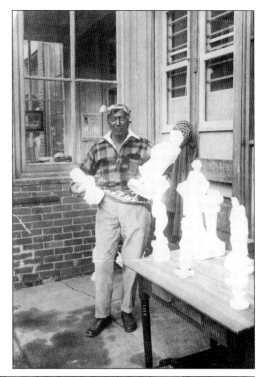

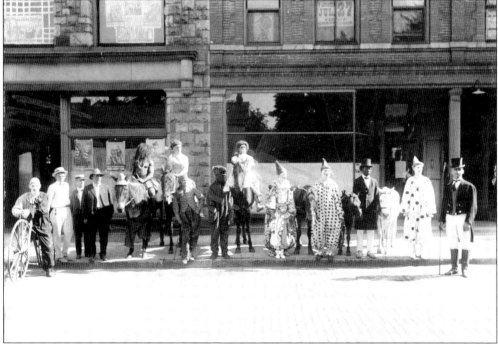

Everyone had so much fun at the first Alley Festa that they held a second one in July of 1918. The second was a great success, breaking all the records of the first. On the first night, all the food venders sold out, and someone had to move quickly to find more food to sell. Although the Alley Festa was a great success, it was never held again.

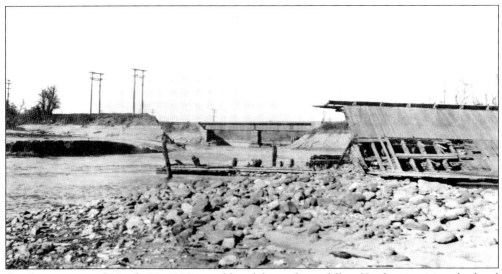

On the morning of March 14, 1918, a sudden deluge of rain fell in Ypsilanti, raising the level of the Huron River, already high from the spring melt. This was too much for Superior Dam, north and west of the city, which gave way at about 4:00 a.m. The dam sent a wall of water three or four feet high down the river. The rushing water, carrying heavy cakes of ice, caused widespread damage. This photograph shows Superior Dam after the flood.

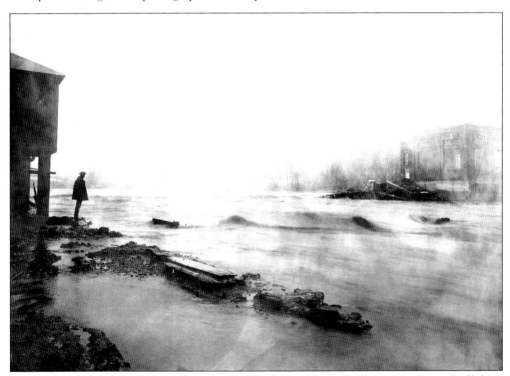

The wall of water continued on down the river and washed out the Peninsular Paper Mill dam, which had been built two years before. The rushing waters carried away the bridge at the mill, and inundated the immediate area. This photograph shows the Peninsular Paper Mill Dam after it had been washed away by the flood. The Edison power house stands on the north side of the river.

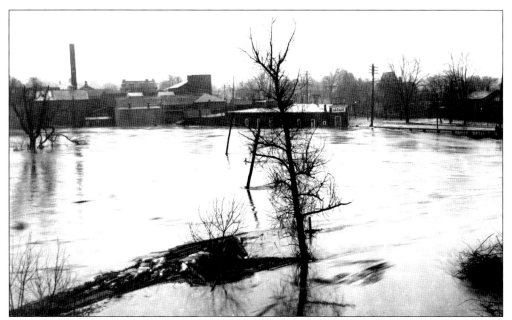

The waters of the Huron River rose 12 feet in ten minutes, as the rushing water uprooted trees and carried off fences from along its banks. For a time, water flowed over the east end of the Michigan Avenue Bridge. The bridge is just visible to the right in this picture.

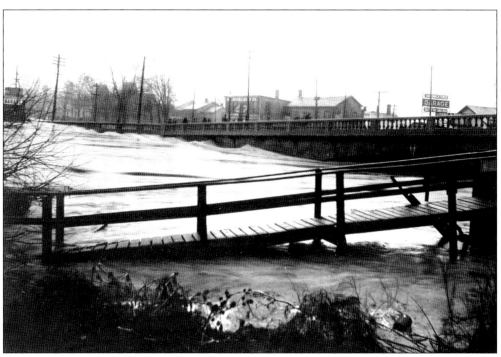

The water flowed over the east end of the Michigan Avenue Bridge with such velocity that the Dolson garage building, which was made of brick, was wrecked. As curious spectators watched, the walls caved in and the roof sank. The cars stored inside had been removed before the waters hit, but the tools and equipment were damaged or washed away.

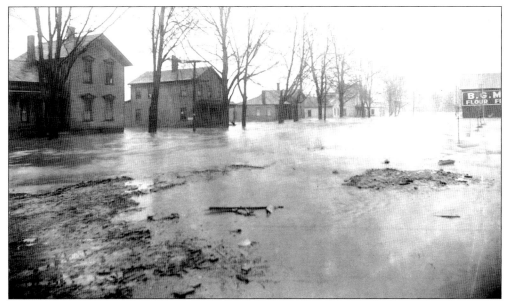

Residents of Water Street were warned of the coming flood, and all but two families escaped from their homes. The two remaining families were removed by boat. The lower area had been flooded just two weeks before.

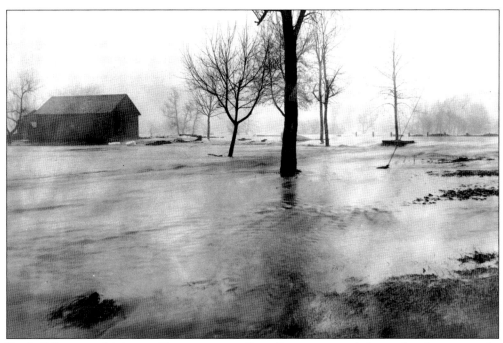

Frank Gilbert was driving a milk wagon across Race Street at an early hour when he was caught by the wall of water. The wagon was washed from the roadway. Gilbert succeeded in loosening the team of mules from the wagon, and the mules and wagon were carried up among the houses. Gilbert was carried downstream some distance before he was able to free himself from the grip of the current. This photograph shows the area near the Water Works, which was almost completely surrounded by water.

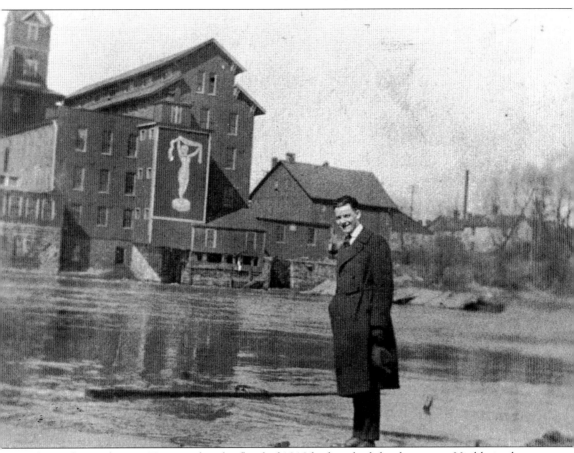

This is the Underwear Factory after the flood of 1918 had washed the dam away. Visible in the photograph is an image of a young woman on the side of the factory, the Ypsilanti Underwear Lady, which was clearly visible to passengers on the trains of the Michigan Central Railroad. The company received many complaints from incensed travelers. It is said some on the train carefully chose their seats so that their sensibilities would not be offended by the sight of this pornography. Others, it is said, carefully chose their seats so their sensibilities would be.

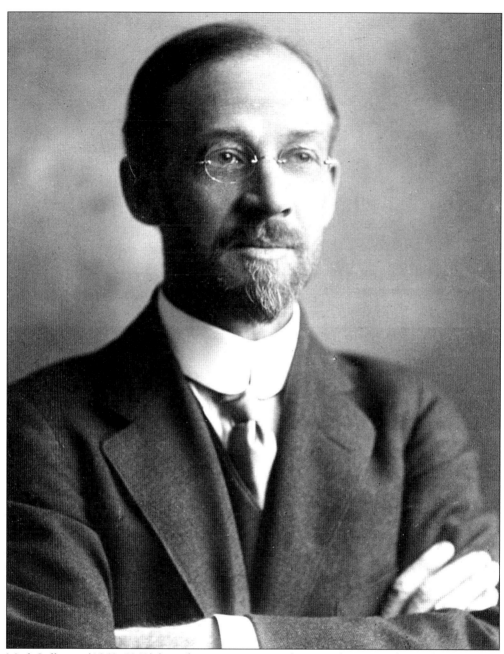

Mark Jefferson (1863–1949) brought a contagious enthusiasm for geography to the Michigan State Normal College. During his years at the Normal (1901–1939), it is estimated he personally instructed 15,000 students, a good number of whom entered the field of geography and several achieved prominence. Jefferson was the chief cartographer for the American Delegation to the Paris Peace Conference at Versailles following World War I. At the conference, Jefferson personally oversaw the drawing of over 1,200 maps. The maps were concerned with such subjects as national boundaries, language, and religion. The maps made by the American delegation were considered superior to those prepared for every other delegation. (Photo courtesy of Eastern Michigan University Archives.)

Three
THE 1920S

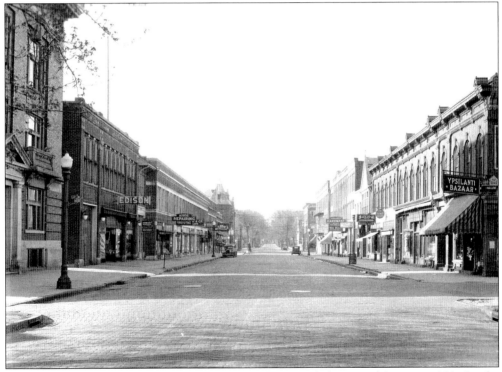

This is an early morning view of Huron Street, looking south from Pearl Street in 1929. On the left is the Masonic Temple, with the Edison Building next to it. Just visible in the distance is the Starkweather Fountain, standing in front of present-day City Hall.

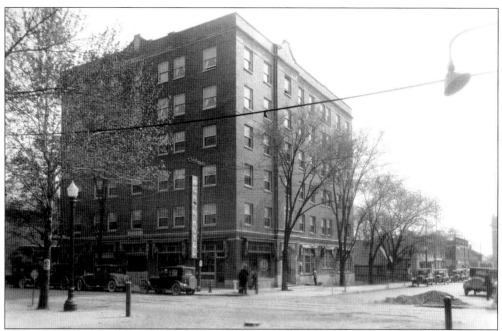

The Ypsilanti Board of Commerce was founded in 1920, and asked its members what it should do for the city. The most popular project was the construction of a new hotel. So the board got to work, secured property on the corner of Washington and Pearl, and began selling stock to the citizens of Ypsilanti. The new hotel, named the Huron Hotel, opened its doors for public inspection on January 1, 1923.

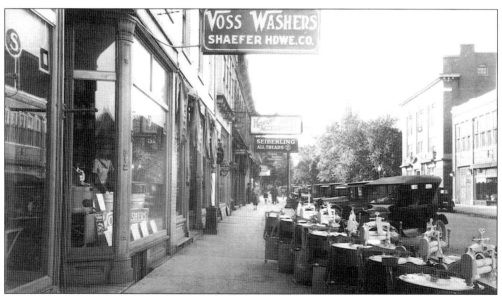

The Shaefer Hardware Store was still at 23 North Huron when this picture was taken in the late 1920s. Notice the up-to-date washing machines on display by the curb. The Shaefer Hardware Store is no longer at this site, as the building was demolished in the late 1950s to make room for a parking lot. Across the street are the Edison building and the Masonic Temple, now the Riverside Arts Center.

Estelle Downing (1869–1950) was the first woman elected to the Ypsilanti City Council, in 1921. She could have possibly been the first woman elected to a city council in the state of Michigan. She was a professor in the English Department at the Normal College from 1898 until her retirement in 1938. To Miss Downing, a good teacher was one who had a clear mind, a warm heart, an emotional life, and a love for people and work. Her goal was to inspire her students to reach beyond their presumed limits and set themselves new and higher goals. Downing Hall was named in her honor in 1957. (Photo courtesy of Eastern Michigan University Archives.)

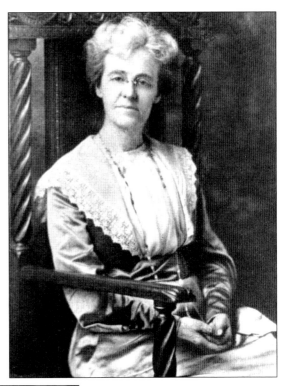

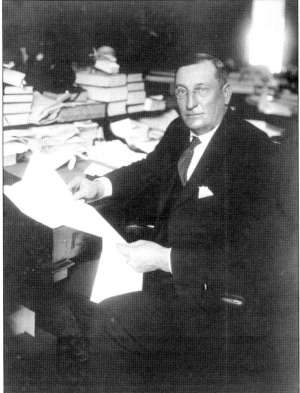

Joseph E. Warner was a member of the Michigan State Legislature for three decades, except for six years in the 1930s. In 1921 Warner fought for a gasoline tax as a way to finance state highway construction. He believed in state support for higher education, and in 1937 wrote what may have been the first teacher pension bill to become law. "He was not one who permitted partisanship to interfere with what he thought was the right thing to do," said Michigan Governor G. Mennen Williams at his funeral.

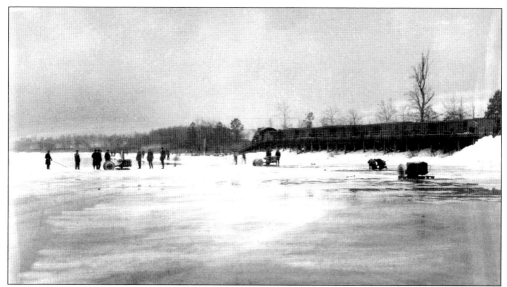

Shanghai Pit was a site on the Huron River to the north and west of Ypsilanti, directly north of where Saint Joseph Mercy Hospital is now. The site was called Shanghai Pit because, it is said, the Michigan Central Railroad employed Chinese workers at the gravel pit that was there. How long the men remained there, where they stayed, and what became of them is now forgotten. For most of the 19th and part of the early 20th century, the Michigan Central sent crews of men to Shanghai Pit to cut ice for their ice houses in Detroit.

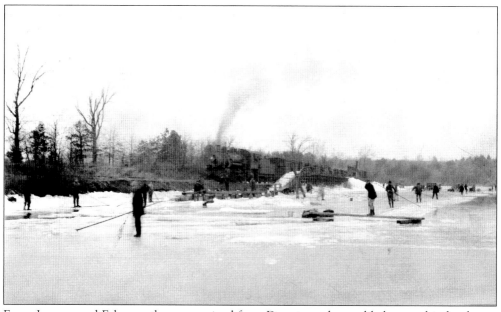

Every January and February the men arrived from Detroit, and most likely stayed in bunk cars provided by the railroad. They began the ice harvest by clearing snow from the frozen surface of the river. Then the ice was marked into sections in a checkerboard grid. A plow was run over the grid until the ice broke lose, and then the men, using poles, pulled the blocks of ice out of the water. The blocks were several feet long and 12 to 15 inches thick.

Finally, the ice was packed in sawdust obtained from a local sawmill, and loaded onto a train for shipment to Detroit. When the work was done, the Michigan Central paid the men a wage between $1 and $1.50 a day, and set them loose on the community. Now the men had money, energy to burn, and a thirst for trouble. They left Shanghai Pit and set out for the closest saloon. There they spent their money, got drunk, started fights, and ended up in jail.

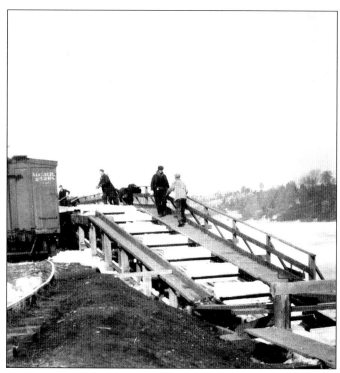

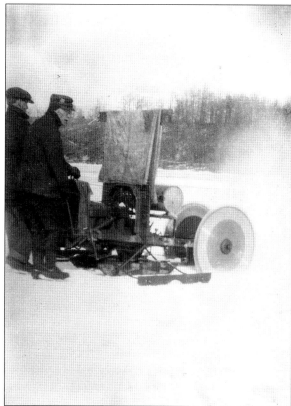

The last year the Michigan Central harvested ice at Shanghai Pit was in 1922, when the contract went to the Dawson Brothers. Charles L. McKie obtained four Model T engines from E.G. Wiedman, a Ford dealer, and mounted them on sleds. These provided power for circular cross saws with a 48-inch diameter. After that, the technology of refrigeration made the harvest of ice unnecessary. Today, Shanghai Pit is a nature preserve.

A Department of Rural Education was organized at the Michigan State Normal College in 1919. Now all President McKenny needed was to find someone to run the department. He found what he was looking for in Marvin Summers Pitman. For vision, energy, and dynamic personality, a better choice could scarcely have been made. During his 13 years of service at the Normal, Pittman established a national and international reputation in rural education. In fact, Pittman found a need for his services and expertise just outside the Ypsilanti School District. (Photo courtesy of Eastern Michigan University Archives.)

The 63-square-mile area south of Ypsilanti was served by 13 school districts, each with a single one-room school house. These schools had no running water, electricity, or indoor toilets. Some children had to walk 2 or 3 miles a day, no matter how harsh the weather, to attend school. The number of students who attended class was determined by the number of school-age children in the district. A district could have 30 children or 100 all in the same classroom taking instruction from one teacher.

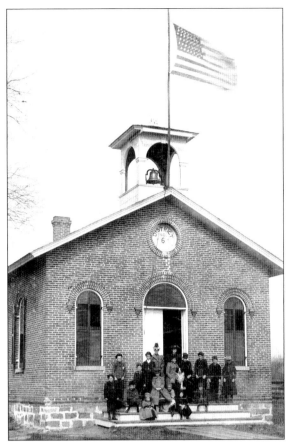

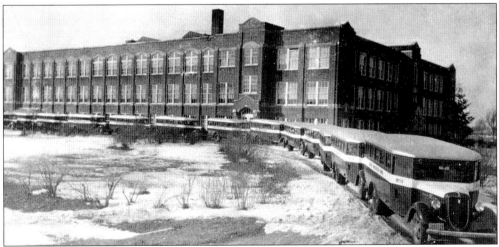

On May 2, 1923, voters in 12 school districts voted 279 to 210 for the consolidation of the school districts. A 13th school district, the Vadder School, petitioned to be included on July 22. The new school opened its doors and admitted its first students on October 31, 1924. The school was named after President Abraham Lincoln, because it was the fulfillment of the ideals for which he stood: equal educational opportunity for rural as well as urban students. (Photo courtesy of Eastern Michigan University Archives.)

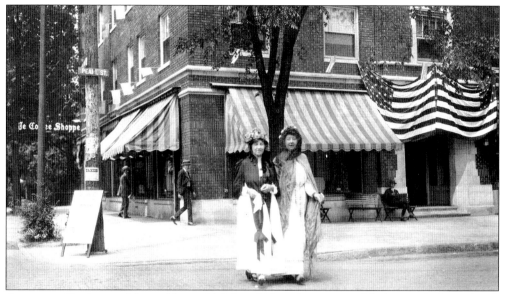

A visitor to Ypsilanti in May and June of 1923 could have been excused for being a little confused, as the young ladies of the city were attired in the fashion of a century before. The ladies were not behind the times, but getting ready to celebrate the centennial of the founding of Ypsilanti. Here two young women cross Pearl Street, in front of the recently opened Huron Hotel.

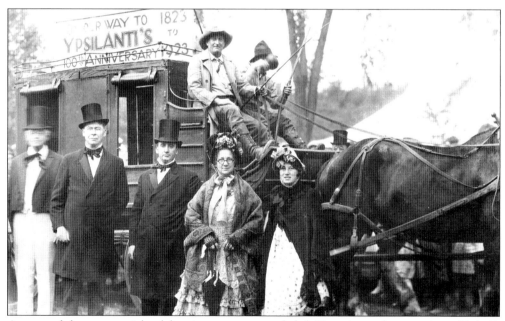

As part of the centennial celebration, a stage coach left Detroit on the morning of July 2, 1923, to recreate the means of transportation available a century before. The driver was Michigan State Representative Joseph E. Warner and the passengers were Miss Mary Hoover, Miss Jane Forbeen, and Luman Seamans. Still, it was a perilous journey for the driver and passengers, who were held up by an outlaw gang, called the Rotarians, just east of Dearborn and forced at gun point to attend a dinner in their honor. Once they escaped that horror, the driver and passengers continued on to Ypsilanti.

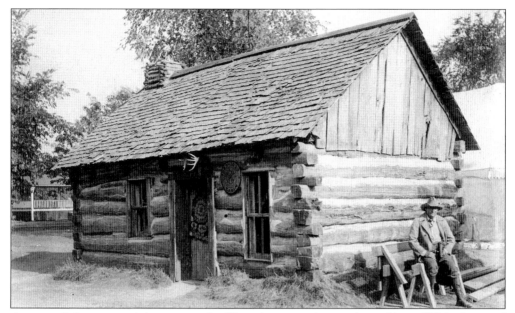

As part of the centennial program, the Kiwanians tore down a log cabin at Whittaker, and successfully put it back together again in Gilbert Park in Ypsilanti by 6:30 p.m. that evening. Some of the logs were so heavy that it took 12 men to handle them. The reason for the cabin was to arouse the pioneer spirit in children. After the Centennial, the Kiwanians gave the cabin to the city, but no one took care of it, and it was demolished in 1928.

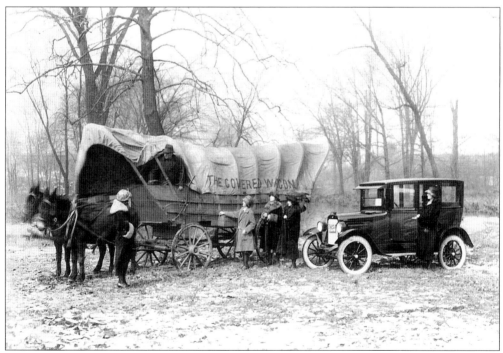

How things have changed in a hundred years. A covered wagon came to Ypsilanti as part of the centennial celebration. It stands here next to the modern automobile.

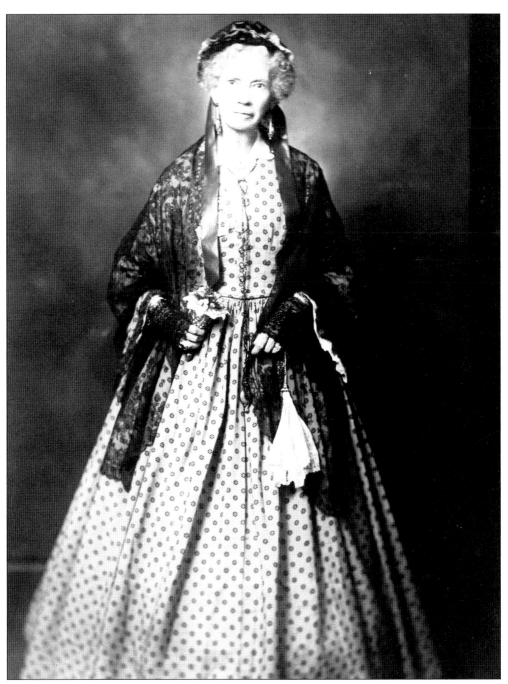

Florence Smalley Babbitt (1847–1929) was one of the first and foremost collectors of Americana in the country. After the death of her husband, Judge John Willard Babbitt, in 1901, what had been a hobby became a vocation and business. She was considered an authority on antique pottery, fine porcelains, glassware, and old English and American silver. She advised Henry Ford on the acquisition of antiques, after he founded Greenfield Village. Active in the community, she is seen here in the 1820s dress she wore for the 1923 centennial celebration. The dress is now on display on the second floor of the Ypsilanti Historical Museum.

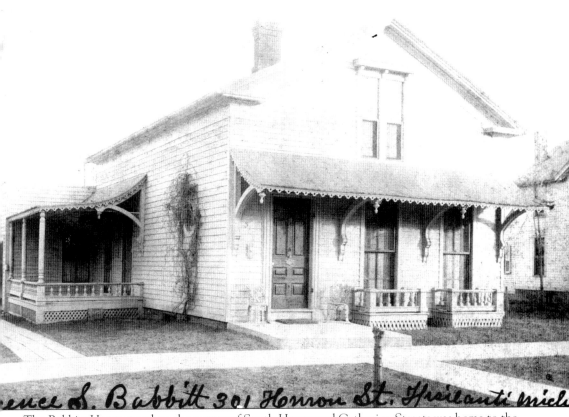

ence L. Babbitt 301 Henron St. Ypsilanti Mich

The Babbitt House stood on the corner of South Huron and Catherine Streets was home to the Babbitt family for 58 years. It was said to have been the oldest house in Ypsilanti. The house had the first bathroom in town. It also housed Mrs. Babbitt's collection of 2,500 dishes. Over the years, the Babbitt family added 13 rooms of good size to the house. One daughter said she sometimes wondered of the additions were intended to house a growing family, or her mother's growing collection. The house was demolished in 1935, after standing empty for years.

John F. Barnhill (1876–1941) came to Ypsilanti from Kansas in 1923, as associate professor mathematics at the Michigan State Normal College. He and his wife at once entered into the life of the community, and soon discovered that the city did not have a band, and, in fact, neither did the Normal College. Barnhill found this state of affairs deplorable, as every four corners in Kansas had either a band or a drum corps. To correct this oversight, Barnhill organized a band unit at the college, and in 1924 he organized the Ypsilanti High School Band. Then in 1936 he organized the drum and bugle corps, the first of its kind in Michigan High Schools. He is best remembered today for the Community Band concerts held in the park. The Ypsilanti Community Band carries on the tradition.

The Michigan National Guard Armory was built in 1923, and stood at 1025 South Huron, just south of I-94, where it was visible to thousands who drove past. Although primarily a military installation, the Armory was used by the local community to host wrestling matches, antique car and hot rod shows, retirement parties, wedding receptions, and other events. The Armory was demolished in 1989, to make room for the Radisson on the Lake complex.

John Engel was a longtime member of the Lutheran Church at Ypsilanti, who donated the lot at 201 North River to the church as the site of a new building. The cornerstone was laid on August 28, 1922, and the church was dedicated on December 23, 1923.

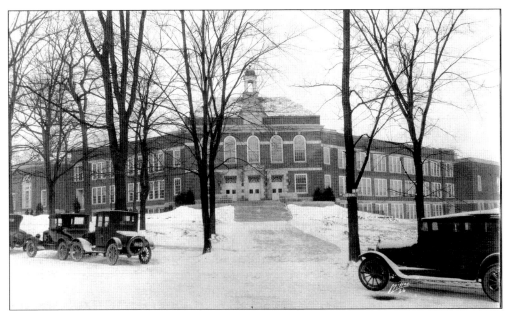

To train high school teachers at the Michigan Sate Normal College, Normal High School was organized in 1900 and first met on the second floor of the main building. The location was far from ideal as the ventilation and lighting were insufficient and conditions were crowded. The legislature finally appropriated $500,000 for the construction of a new school on the Normal campus. Ground was broken for the new building, named Roosevelt High School in honor of President Theodore Roosevelt, on May 5, 1924. (Photo courtesy of Eastern Michigan University Archives.)

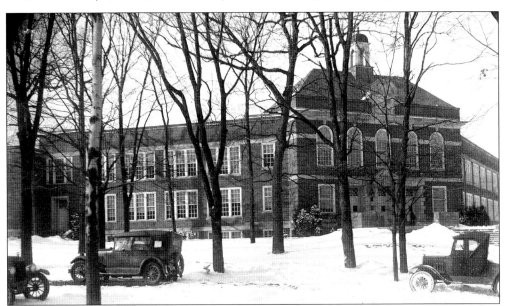

Roosevelt High School was divided into units, with a unit for each department. Each department had a room measuring 23 by 30 feet, with a small room, 15 by 22 feet, at each end of the larger room. The departments included mathematics, history, art, geography, chemistry, biology, agriculture, domestic science, and printing. The building also had an auditorium, gymnasium, swimming pool, cafeteria, and library. (Photo courtesy of Eastern Michigan University Archives.)

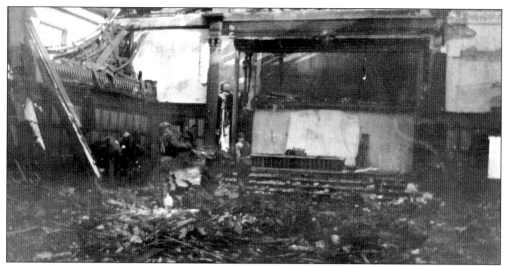

A fire of undetermined origin started in the basement of the Masonic Temple at 76 North Huron on the afternoon of November 29, 1924. Flames were seen bursting through the roof just before 6:00 p.m. Firefighters put the fire out after four hours. The fire left the upper floors a mass of charcoal and debris. This photograph shows the third floor lodge room after the fire. The loss was estimated at $100,000. The building was repaired and rededicated in June of 1925.

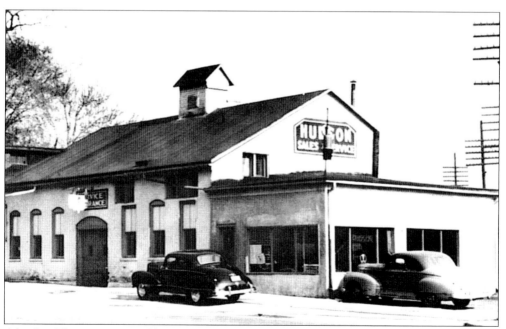

After Joe Thompson moved his Dodge dealership from 100 East Cross in 1925, Miller Hudson Sale & Service moved in. The Miller Hudson dealership remanded in business long after the Hudson Car Co. went out of business in the 1950s. Today, the building is the home of the Ypsilanti Automotive Heritage Collection.

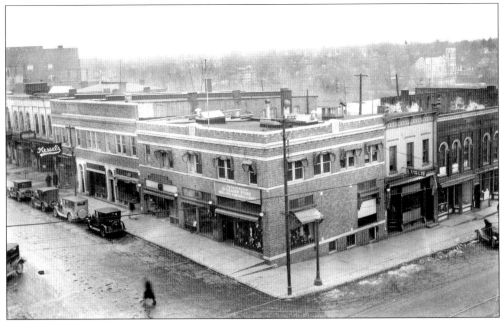

This is a view of the northeast corner of North Huron and East Michigan Avenue in the 1920s. Just visible to the right is Emmanuel Lutheran Church on River Street.

Riverside Park is pictured as it was seen from the Michigan Avenue Bridge in 1927 or 1928. Emmanuel Lutheran Church is just visible to the right. For many years the flats of the river were private property, and unavailable to the public. Then, beginning in1915 and continuing into the 1930s, the city acquired the land piece by piece. The land became the property of everyone.

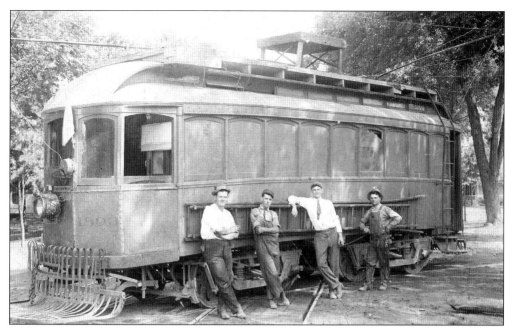

As the interurban made travel by horse obsolete, the speed and convenience of the automobile made the interurban obsolete. Once someone had a car, they could go where they pleased, when they pleased, and were no longer depended on a schedule provided by a transportation company. The last run of the interurban in Ypsilanti was made in 1928, when the interurban company went out of business.

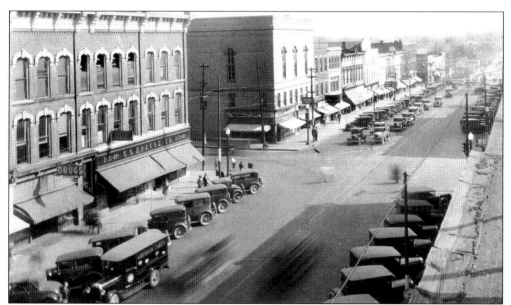

This photograph depicts angle parking on Michigan Avenue in 1928 or 1929 looking east. The building at the northeast corner of Michigan and Washington Street is Hewitt Hall. The top floor was a theater and later the armory for the Ypsilanti Light Guards, as the local unit of the National Guard was then known. The upper floor was removed soon after this picture was taken, most likely because of structural problems. The two lower floors are still there today.

Pictured is North Huron Street as it appeared *c.* 1929. To the right is the Daniel L. Quirk home. Note the streetlamp near the top center of the picture.

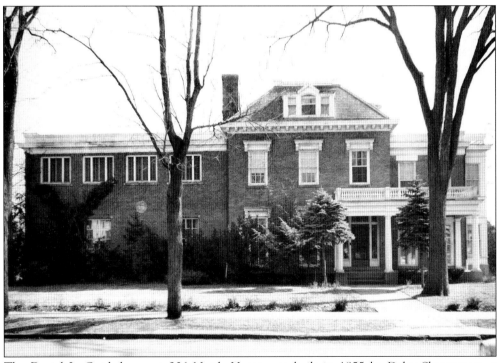

The Daniel L. Quirk home at 206 North Huron was built in 1855 by Delos Showerman, a haberdasher, in a cubic Italianate style with a slate hip roof. The house was sold to Daniel L. Quirk on October 23, 1908, had he had additions made to the house in the Georgian Revival style. He had the north wing added in 1927 to house his extensive library on theatrical and circus history.

Behind his house, Daniel L. Quirk had a garden the size of two tennis courts, as well as a lawn tennis court. Quirk's daughter Nancy married G. Mennen Williams, who during the 1950s was the Democratic Governor of Michigan. At the same time, Quirk's son Daniel T. was the Republican mayor of Ypsilanti. For some time, politics were forbidden from discussion at family gatherings.

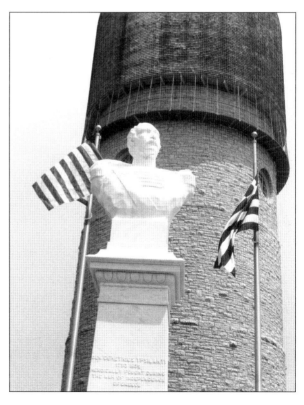

The city was named in honor of Demitrius Ypsilanti, hero of the Greek War of Independence. The American Hellenic Education Progressive Association (AHEPA), an international organization that promotes Greek cultural heritage, presented the city with a marble bust of its namesake. The dedication was held on August 29, 1928, and was attended by 5,000 members of AHEPA.

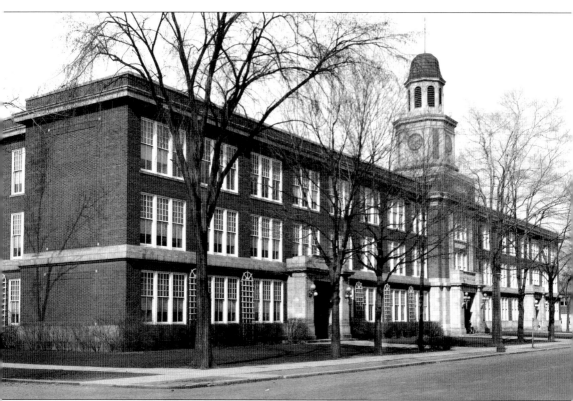

The old Union School Building on the northeast corner of Cross and Washington was razed in 1929 to make room for the east wing of the high school. The main entrance was at the center of the building, where the two wings come together. In the tower above the entrance is the bell from the old Union School Building. The bell remained in use until the graduation of the last senior class in 1972. Today the building is Cross Street Village, a senior community, of whom many are Old Ypsi High alumni.

Four

THE 1930S

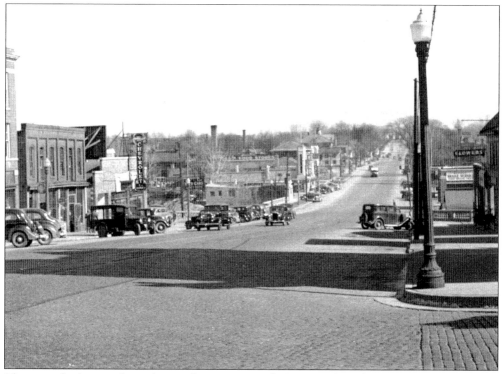

This view looks east from the southeast corner of Huron and Michigan Avenue during the 1930s. It is said that during the Great Depression, there was so little traffic on Michigan Avenue that grass grew through the crack in the center of the road.

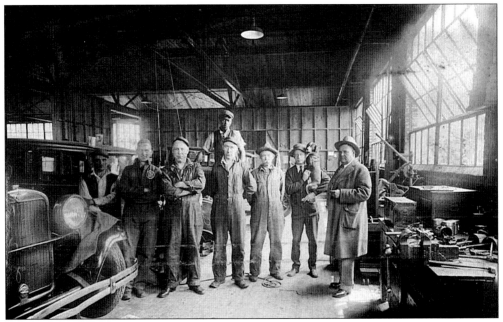

Joe Thompson moved his Dodge dealership from Cross Street to a new building on Michigan Avenue in 1925. Here are the men who manned the service department in 1930. Joe Thompson is standing at the right.

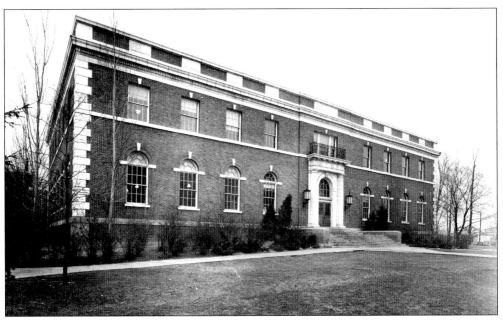

In 1926 some $250,000 was appropriated for the construction of a new library at the Michigan State Normal College, now Eastern Michigan University. Work on the new building was finished by January of 1930, and it opened for use on January 7, 1930. The building remained in use as the library until 1966, when the second library building opened. It was converted to use by other departments, and was renamed Ford Hall. (Photo courtesy of Eastern Michigan University Archives.)

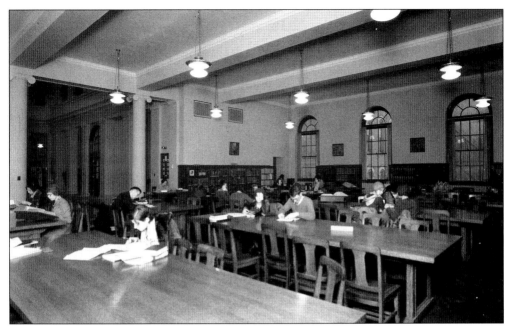

The new library had three reading rooms with enough space to accommodate 450 people. Two of the rooms were on the first floor, and the third was on the second. This photograph shows the main reading room from the northwest side. (Photo courtesy of Eastern Michigan University Archives.)

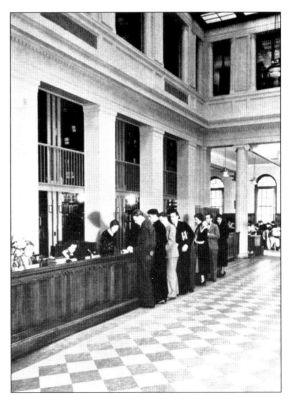

The building of the new library was the crowning achievement in the career of Miss Genevieve Walton, who presented a glass-covered delivery desk to the new building. (Photo courtesy of Eastern Michigan University Archives.)

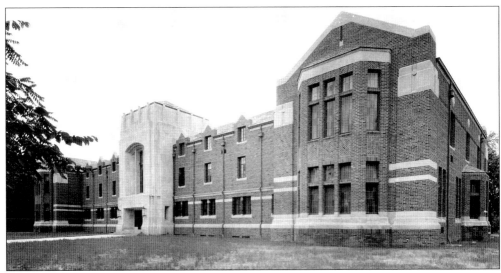

Michigan State Normal College President Charles McKenny was holding a meeting with student leaders in 1924 to discuss social matters, when he suggested the possibility of a building to serve as the social center of the campus. The idea, it was later reported, fell "like a spark in dry grass and flashed up into the flame of enthusiasm." A major fund drive was started, and continued even in the face of the Great Depression. The cornerstone was laid by President McKenny on January 17, 1931. By then the Alumni had voted to name the building after McKenny, who had worked so hard to make it a reality. (Photo courtesy of Eastern Michigan University Archives.)

This little pillared house stood at 126 North Huron Street, just south of the Ladies' Library building, until it was razed in 1932 to provide a suitable entrance to the park behind it. The house was built c. 1860 and was known as the Finley house. When the house was demolished, it was found not to have a single nail in it; instead, it was built with wooden pegs.

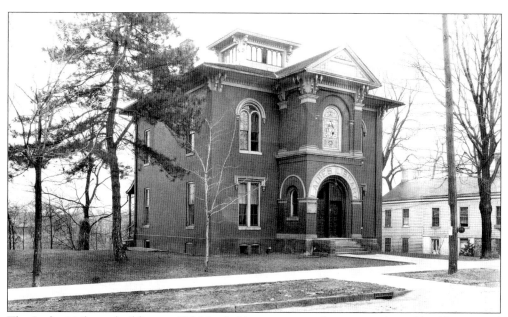

The Ladies' Library building at 130 North Huron remained in use as the public library until 1963, when the library was moved into the old post office building on Michigan Avenue. This undated photograph shows the house when it was still the public library. To the right of the library is the Finley house.

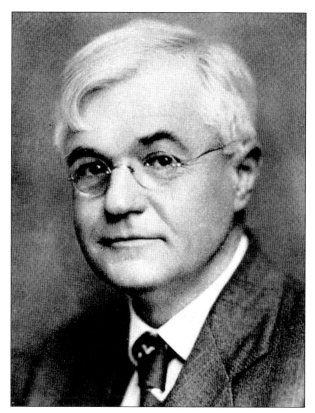

Carl Esak Pray (1870–1949) was made head of the History Department in 1914, and was only the second male to join the department. A wonderful storyteller, when he told a story about George Washington, his audience felt as if they were in the presence of Washington himself. A very handsome man, it is said almost every coed at the college had a crush on him. Popular with the students, he was affectionately known as "Daddy Pray."

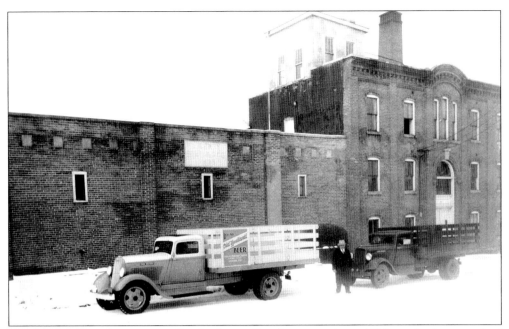

The old Foerster brewery on South Grove Road reopened in 1933, with the repeal of prohibition. The property was purchased by Christ Vogt who installed new machinery and used trucks to distribute his product over a larger area. Vogt called his business the Ypsilanti Brewing Co. and his product Old Ypsilanti Beer.

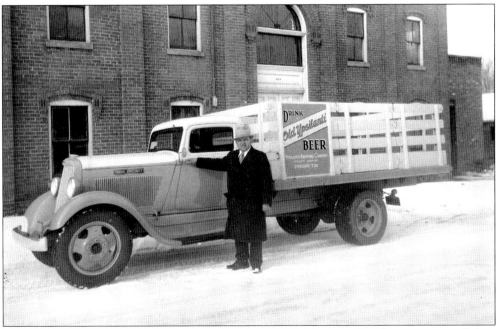

The new company was in trouble from the start, as it faced competition from Detroit and Ann Arbor. The Ypsilanti Brewery struggled until 1941, when new ownership changed the name to Dawes. The brewery closed for good in 1941. The equipment was sold to the Altes Brewing Co. of Detroit. The old brewery was later demolished in order to make room for industrial development.

The Starkweather fountain was dismantled and placed in storage in April of 1932. The city planned to erect the fountain in the park behind the Ladies' Library building on North Huron Street. Nothing came of the plan; instead the top part of the fountain, the figure of Hebe, was moved to Tourist Park, now Waterworks Park in 1933. There she graced the entrance to the park. Since then, the fountain has completely disappeared.

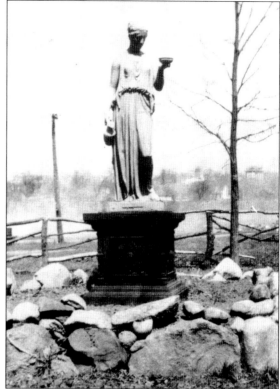

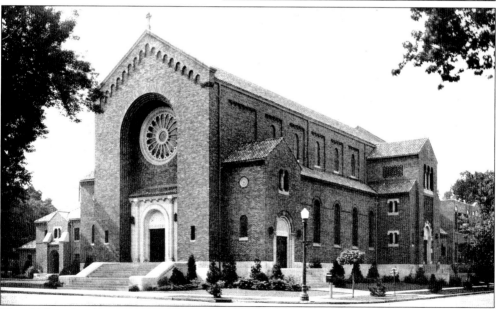

The old St. John the Baptist Catholic Church was demolished to make room for a new building, but the Great Depression hit before the work was completed. Services were held in the basement for several years, as that was the only part of the building that was finished. Work on the Romanesque church was finished under the leadership of Father G. Warren Peek. The new church was dedicated on June 4, 1933.

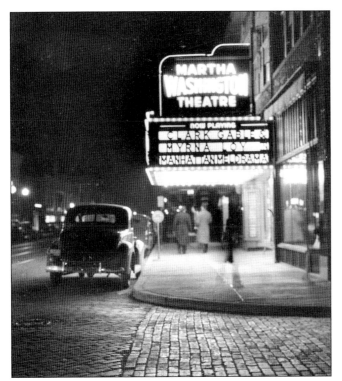

This photograph shows how the Martha Washington theater, on Washington Street, looked in 1934. Built by Florence Sigor in 1915, it was a favorite family movie house into the 1970s. Then the theater closed, and the building has since been used for entertainment of a different kind.

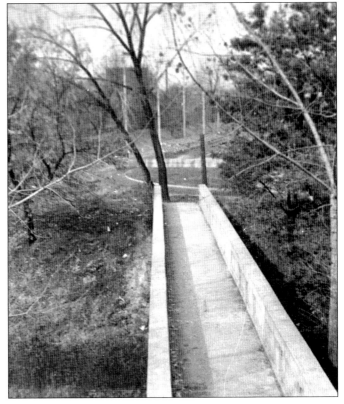

The footbridge that connects Cross Street to Frog Island was built by WPA Workers in March of 1934. Frog Island was then the athletic field for the Ypsilanti High School, then on Cross Street. There the football team played, and the track team ran. Today, Frog Island is a public park, with room for soccer, football, and jogging. The bridge is still in use.

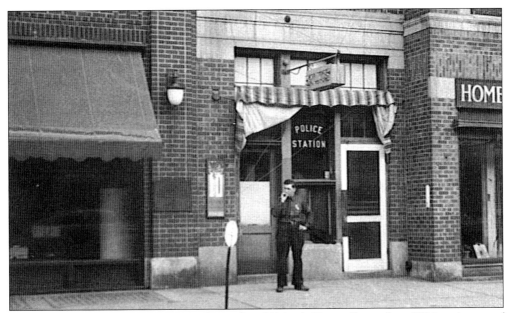

The Ypsilanti Police Department was located at 56 North Huron Street from 1934 to August of 1943. The police remained here until the department moved into new quarters on Washington Street in 1943. The move may have been made because the department had to pay rent for the use of the building on North Huron.

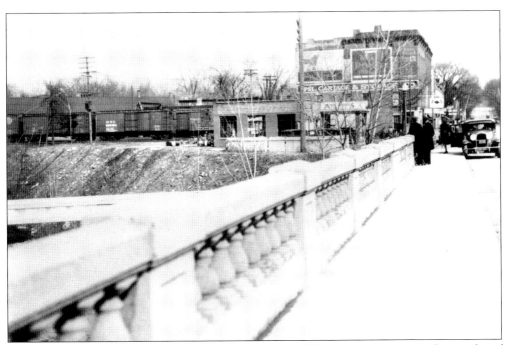

This photograph was taken on March 8, 1935, as part of the investigation into the murder of eight-year-old Richard Streicher. The body was found that morning under a ledge under the footbridge connecting Frog Island to Cross Street. Streicher had been stabbed fourteen times about the head and chest.

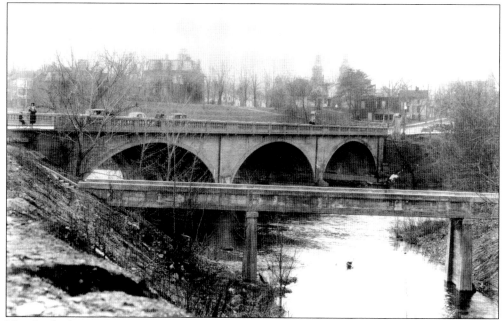

The footbridge connecting Frog Island and Cross Street had been built by WPA workers the year before. Richard Streicher's body was found under the Cross Street end of the bridge, after an all-night search for the boy. When the body was found, the body was perfectly straight and positioned with the arms at the sides.

Streicher was last seen alive the evening before, sledding with a friend at the north end of Riverside Park, then called Quirk Park, when a stranger called him away. Streicher followed the man, dragging his sled behind him.

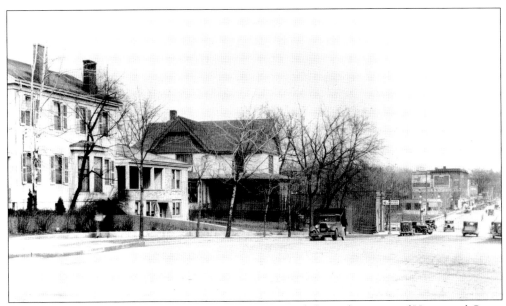

The Streicher family lived at 404 North Huron Street, at left, on the corner of Huron and Cross. After the body was found, Streicher's sled was discovered leaning against a wall of the house, where he always left it. His mother, however, said Streicher was not the one who left it there. Streicher always left his sled with the runners against the wall. This time the runners were away from the wall. The sled may have been returned by the killer. The murder has never been solved.

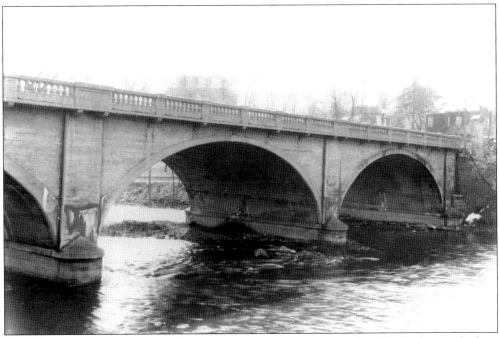

Cross Street Bridge as it appeared at the time of the Streicher murder. The bridge was built in 1910 and was a soil-filled, concrete, spandrel-arched structure typical of the time. It served the community well, but was allowed to deteriorate, and was replaced in 1984.

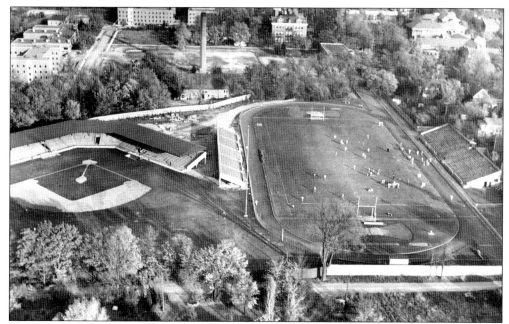

Walter Owen Briggs was born in Ypsilanti on February 27, 1877. The Briggs family moved to Detroit, and Walter grew up to be a successful businessman. In 1936 he became the sole owner of the Detroit Tigers. On January 28, 1937, it was announced that Briggs had made a gift of $150,000 to the Normal College for a new field house, concrete football bleachers, and a baseball grandstand. The gift gave the Normal one of the best-equipped college baseball fields in the nation at that time. (Photo courtesy of Eastern Michigan University Archives.)

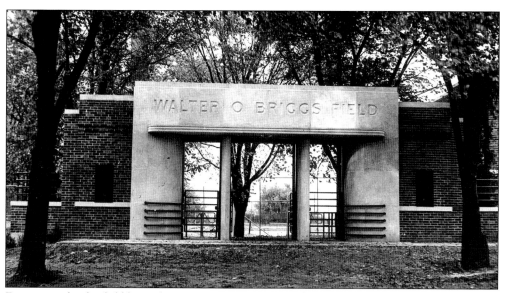

Excavation for the field house began on May 12, 1937, and was completed October 1, 1937. The field house was a one-story brick building with an overall length of 190 feet and a width of 50 feet. The 50-foot-long west wing held lockers, showers, property rooms, offices, and training rooms. The ticket booths and entrance to the field were located at the west end of the field house. (Photo courtesy of Eastern Michigan University Archives.)

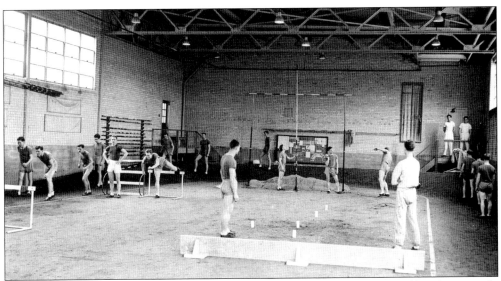

The east wing was 100 feet long and had a dirt floor which was below ground level to provide ample room for pole vaulting and other indoor practice. The roof had to be high enough so that pole vaulters would not become entangled in the girders. Briggs Field was removed in the 1970s, and the building is no longer used as a field house. The interior has been completely remodeled, for one thing, and the east wing no longer has a dirt floor. (Photo courtesy of Eastern Michigan University Archives.)

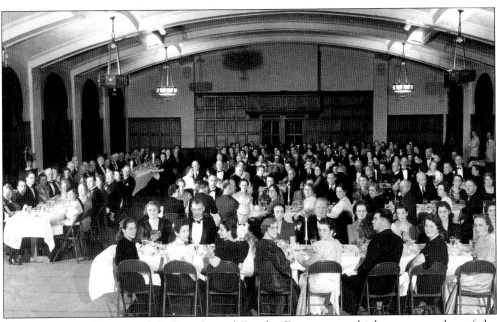

For many years the Normal College hosted Faculty Dinners, at which every member of the faculty was expected to attend. Those members of the faculty who were absent from the dinner without an excuse were soon after looking for a new position. This photograph was taken in the ballroom of McKenny Union in the 1930s. The one person most likely not to be found in the picture is President John Munson, who reportedly had such terrible eating habits that he had to eat in the kitchen. (Photo courtesy of Eastern Michigan University Archives.)

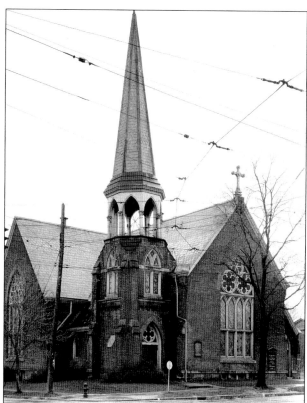

For many years the tall spire of the First Baptist Church on the southeast corner of Cross and Washington Streets was a local landmark. The building was destroyed by fire on the morning of February 19, 1937. According to firehouse lore, people reported the smell of smoke, and firefighters searched the area for the source, but found nothing. No one knew where the smell was coming from until early that morning, when flames engulfed the building.

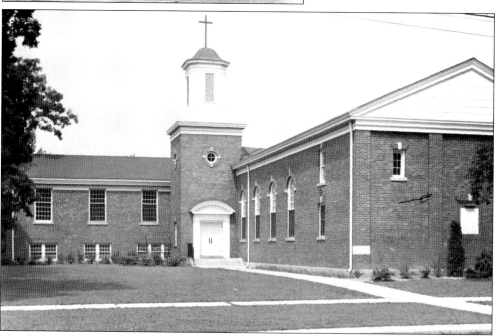

Members of the congregation of the First Baptist Church cleaned 83,000 bricks recovered from the ruins of the old church. These were used in the building of the new church at 1110 West Cross Street.

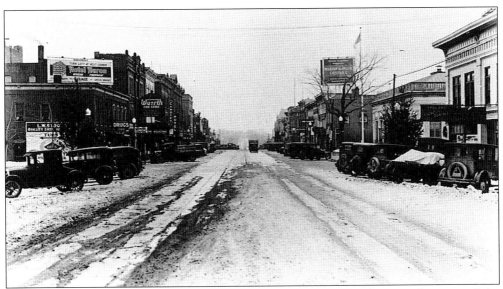

Looking east on Michigan Avenue about 1937. At left is the Wuerth movie theater, and the post office, now the library, is across the street to the right.

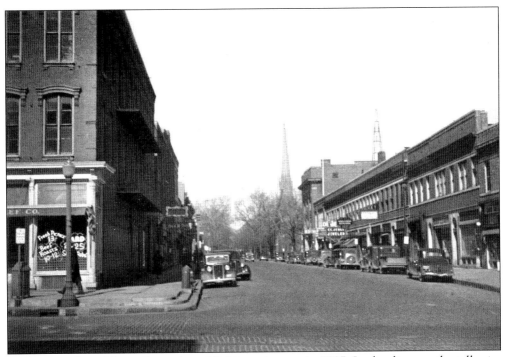

Looking north on Huron Street from Michigan Avenue in 1937. In the distance the tall spire of the St. Luke's Episcopal Church. The Masonic Temple is just to the right of the church.

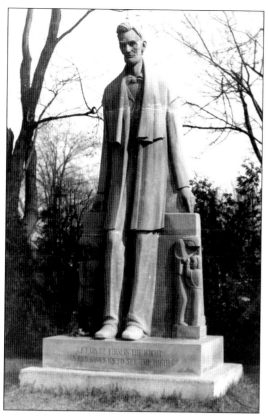

Russian-trained sculptor Samuel Cashwan visited the Lincoln School in the 1930s. Cashwan suggested the school should have a memorial to the man for whom the school was named. He volunteered to do the statue on the condition that its placement would be an all-school project. The statue was dedicated on May 4, 1938. Inscribed on the base are the words: "Let Us be Firm In the Right." (Photo courtesy of Eastern Michigan University Archives.)

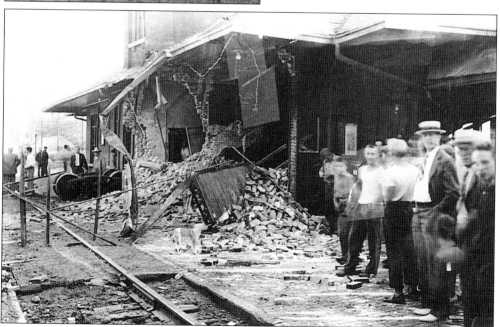

The Michigan Central Railroad Depot at Ypsilanti under went extensive remodeling on August 19, 1939 when a train crashed into the side of the building. There were no injuries, but the depot was damaged. The building was rebuilt, but this time without the second floor tower.

Five

THE 1940s

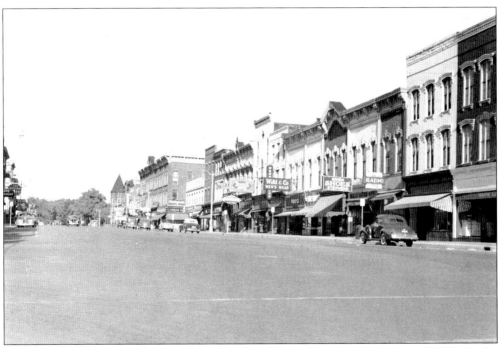

Michigan Avenue is seen here looking west from Huron Street in the spring of 1942. In the distance, Cleary College can be seen, as well as the Union Block, now better known as the Kresge Building. The Kresge Company opened a store in the building in 1929, and remained there until 1966. Then the building stood vacant for several years. The company, now K-Mart, leased the property to a number of tenants. The building is now under new ownership.

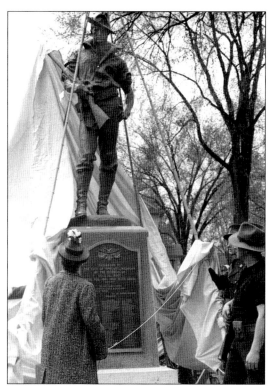

The Hiker, the statue standing at the intersection of Cross and Washtenaw, is a memorial to the men from Ypsilanti who were in the Spanish-American War. The statue was dedicated on May 18, 1940, during the 41st reunion of the 31st Michigan Volunteer Infantry Regiment. On the base of the statue is a list of the men from Ypsilanti who were in Company G of the 31st Michigan Regiment.

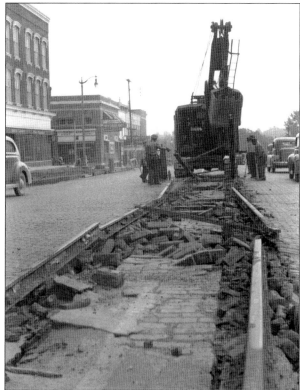

The railroad tracks of the interurban were removed from the streets of Ypsilanti in 1940. Today, little if anything of the interurban remains.

John Milton Hover (1885–1940) was a student of the Michigan State Normal College, who returned in 1919 as Associate Professor of Agriculture and was made head of the Natural Science Department in 1932. In addition to this, he was named Dean of Administration in 1935. He oversaw the care of the campus Science Garden and founded the Garden Project Club in 1922. During the 1920s he supervised the planting of every type of tree native to Michigan on the campus. He was active on campus and in the life of the city as well, and active in many community groups. He died after suffering a heart attack while in a meeting with President Munson. (Photo courtesy of Eastern Michigan University Archives.)

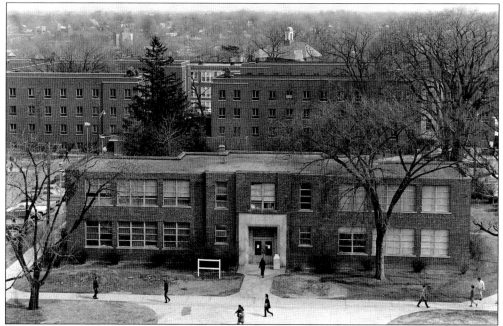

This plain square box of a building was built in 1940, and named for J. Milton Hover, Dean of Administration and head of the Natural Science Department. Professor Hover died Sunday, June 9, 1940, after he was suddenly stricken with a heart attack the day before while in conference with President John Munson. The building had long been the dream of Professor Hover, who said such a building would be beneficial to the students and college. The building was used for the study of biology and botany. It is now used for business and finance. (Photo courtesy of Eastern Michigan University Archives.)

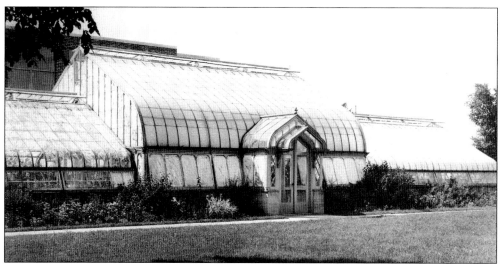

A greenhouse was added to the Hover Building in 1941. The greenhouse was purchased by President Munson for $20,000 from the Erskine Estate in South Bend, Indiana. The entrance on the side of the Greenhouse was removed after World War II. The old greenhouse was removed after a new one was built on the south side of Mark Jefferson. (Photo courtesy of Eastern Michigan University Archives.)

This photograph shows Old Wiard Road east of Ypsilanti in 1941, looking north from south of the Michigan Central Railroad tracks. A quiet peaceful place in the country, that was about to change forever. Not far from here Henry Ford grew soybeans and managed a camp for the sons of World War I veterans. The area was called Willow Run, after a stream that meandered through it.

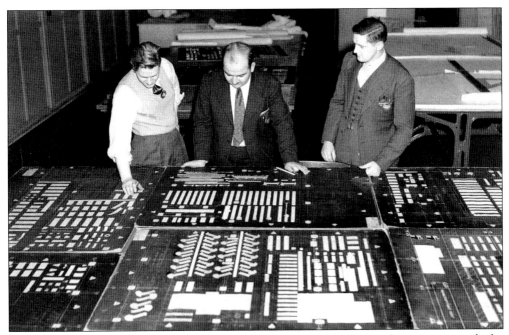

Edsel Ford, Charles Sorenson, and others from the Ford Motor Company visited the Consolidated Aircraft Company in San Diego to see how B-24 Liberator Bombers were built. Sorenson saw that the company was building B-24 Liberator Bombers like a custom-made product. That night he drew up a floor plan of a plant that could build the planes more efficiently. The plans were later made into a model, to make the idea real.

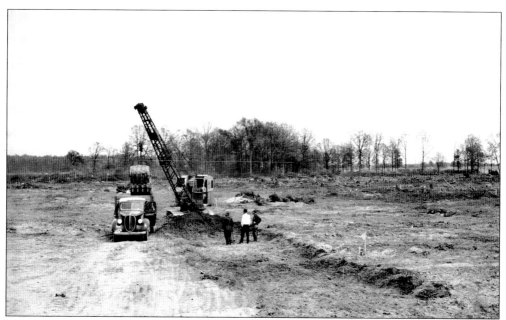

Edsel Ford and Sorenson chose Willow Run as the site for the new plant, and set the survey stakes there themselves. Henry Ford objected because he planned to plant soybeans on the land, and pulled up the stakes several times. Finally, Edsel and Sorenson had a steam shovel begin digging the foundation for the plant early one morning before Henry Ford could stop it. Henry Ford was furious, and did not speak to either Edsel or Sorenson for weeks.

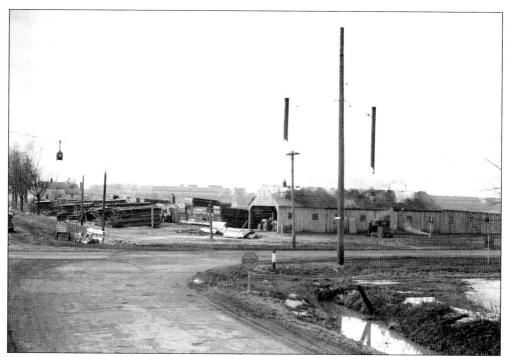

Nothing goes to waste. As the land was cleared for the plant, the trees were turned into lumber at the site. The sawmill at Willow Run is pictured here.

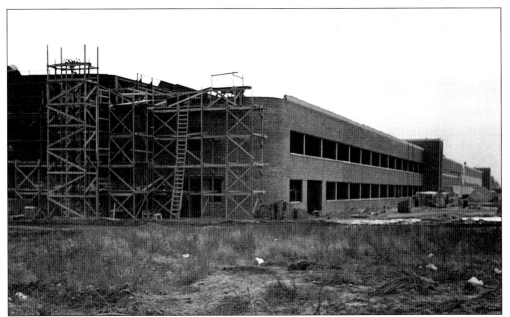

Construction of the plant at Willow Run began in May of 1941, seven months before the attack on Pearl Harbor. The plant was designed by Albert Kahn and was the single largest building project of his career. It had 87 acres under one roof, and was the largest factory in the world. It had 70 sub-assembly lines and mile-long conveyors to move parts from one place within the plant to another. It would also be Kahn's last project, as he died in 1942.

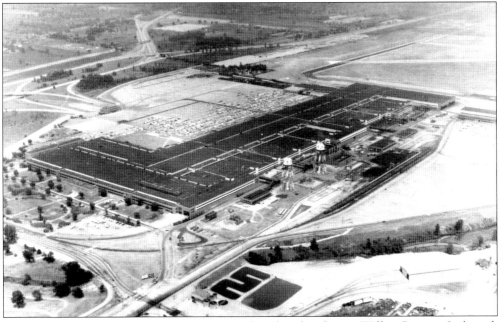

The best shape for an assembly line is a straight line, but the plant at Willow Run was L-shaped. The reason for this was simple: Had the plant been built in a straight line, part of it would have been in Wayne County, which was Democratic in politics and had high taxes, where as Washtenaw County was Republican in politics and had low taxes.

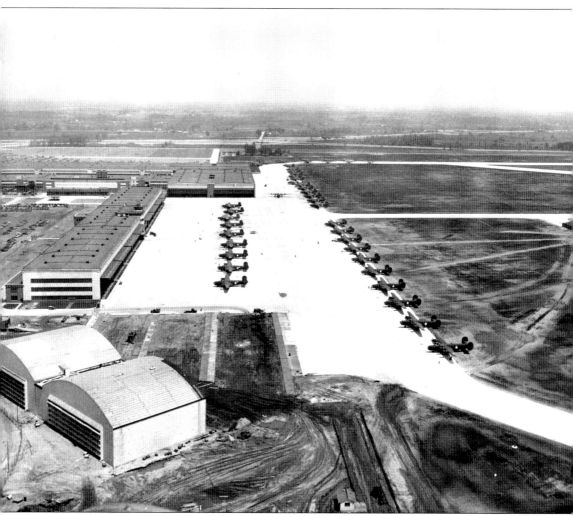

Since the plant built airplanes, it was a good idea to have an airport nearby. For this reason the federal government purchased land adjoining the plant on which to build an airport. Work on the airfield began by July of 1941, and finished in December. The runways were 160 feet wide and about a mile long. The airport had an eight-section hanger to house 20 B-24s.

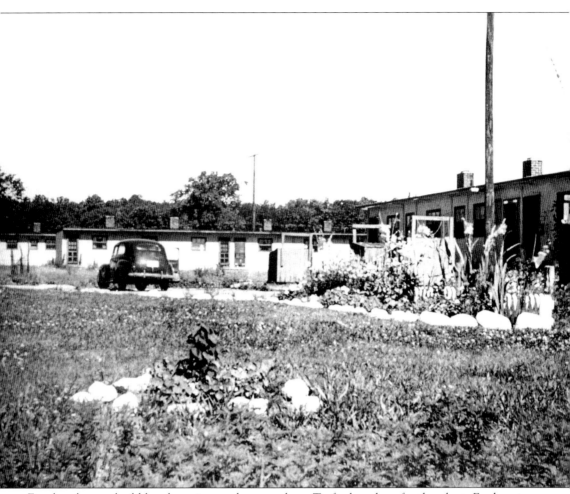

For the plant to build bombers, it must have workers. To find workers for the plant, Ford sent recruiters to the American south to find them. Soon workers were coming from Kentucky and Tennessee, and changed the city of Ypsilanti forever. Overnight Ypsilanti went from a sleepy college town to a blue collar community. A major problem was the lack of housing for the newcomers. Some slept in cars and others in chicken coops. Some families in Ypsilanti rented beds in their home by shifts. One would sleep in the bed, called a "warm bed," then go to work at the plant while another took his place. To give the workers a place to stay, the government built housing near the plant. The "temporary" housing was demolished in the early 1960s.

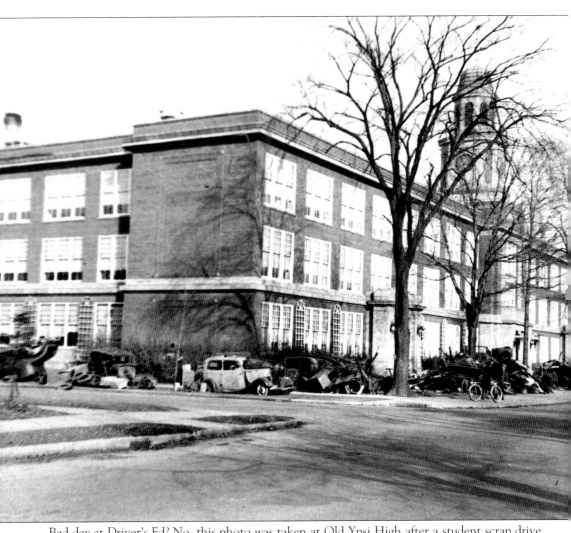

Bad day at Driver's Ed? No, this photo was taken at Old Ypsi High after a student scrap drive during World War II. Nothing was safe from the students.

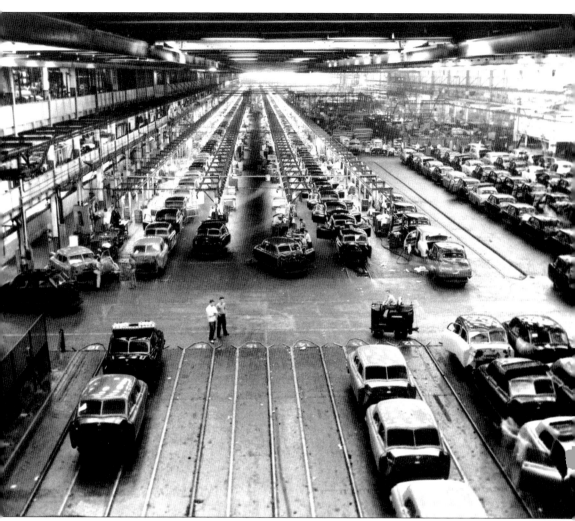

When World War II ended in 1945, the demand for B-24 Liberator bombers ended as well. For this reason Ford ended production of the bomber and closed the plant at Willow Run. The plant stood unused until 1946 when Kaiser-Frazer Corporation bought the plant from the federal government for the manufacture of automobiles. It proved ideal for the conversion to auto production. The 2,650,000 square feet of floor space in the main building, plus 1,040,000 square feet in the balconies, provided space not only for the body presses, body building lines, and storage areas, but also space for an inside railroad with shipping docks with a capacity for more than 76 freight cars. This was the only auto plant where all the operations of car manufacturing took place on one floor and under one roof.

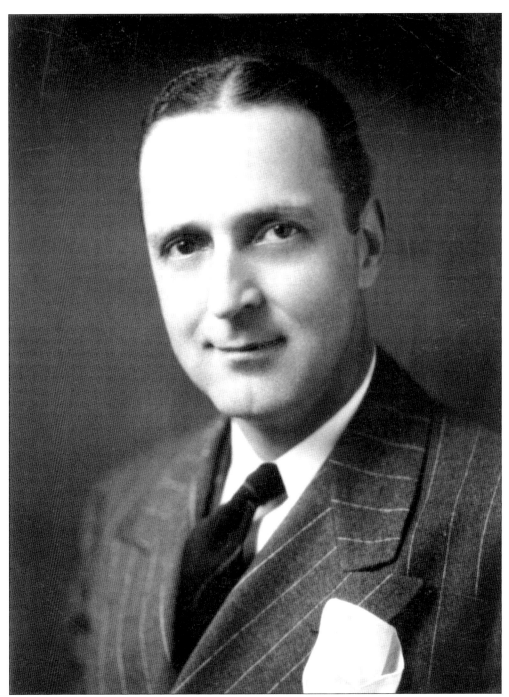

Preston Tucker (1903–1956) was more of a visionary than a businessman. The war had just ended when Tucker unveiled plans for the "Tucker Torpedo," and plans to challenge the major auto makers of Detroit. In 1949, the Securities and Exchange Commission issued a report calling the car "an engineering monstrosity." Then the SEC charged Tucker with fraud. He was acquitted on January 22, 1950. He died in obscurity, before he could reorganize the company. His story inspired the 1988 Francis Ford Coppola movie *Tucker: the Man and His Dream*.

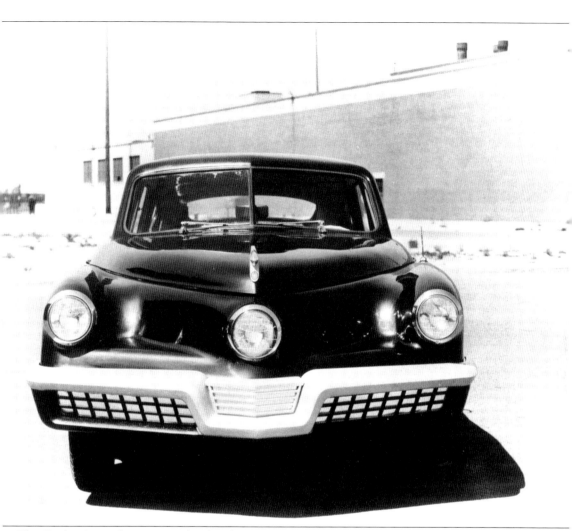

The Tucker Torpedo was a car far ahead of its time. It had features that would not appear on other models until years later, including: torque converter; automatic transmission; individual four-wheel suspension with torsion bar springing; reinforced interior with padded dash; pushout windshield; cut-proof-glass' air-cooled disc brakes; fuel injection; two-cylinder, high compression 150-horsepower engine; steel and plastic body; interior air-conditioning; and headlights that turned with the wheels. A noted feature of the car was the center, or Cyclops, headlight. A total of less than 60 cars were built.

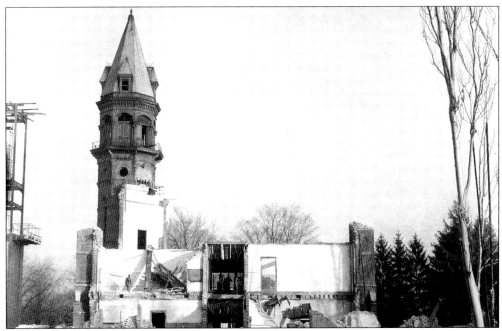

The Main Building of the Normal College was demolished in 1948. Sometimes called Old Pierce Hall, it stood on the site now occupied by the plaza between Boone and the current Pierce Hall. The bell tower was the last part of the building to be razed.

As the Old Pierce Hall was being razed, the new Pierce Hall was under construction. It stands on the site once occupied by the North Wing of the Old Main Building. Over the years, the building has been used to house both classrooms and offices. (Photo courtesy of Eastern Michigan University Archives.)

Six

THE 1950S

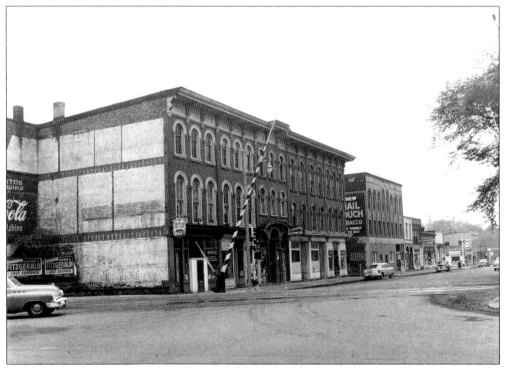

This is Depot Town as it appeared in the 1950s, looking south from the railroad tracks. The building at the center of the picture took on its unusual shape in 1929, after a train jumped the tracks and crashed into it.

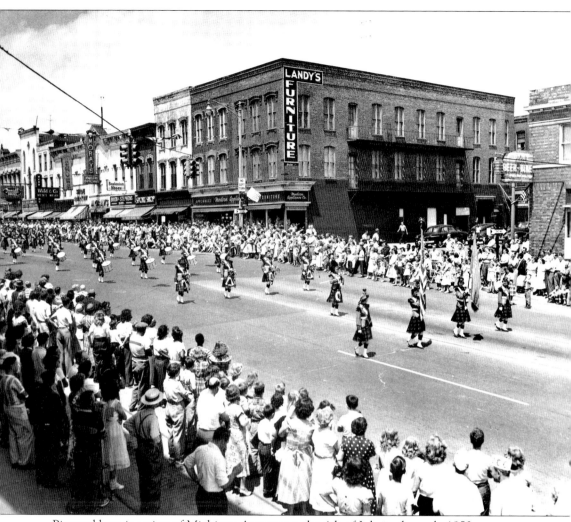

Pictured here is a view of Michigan Avenue on the 4th of July in the early 1950s.

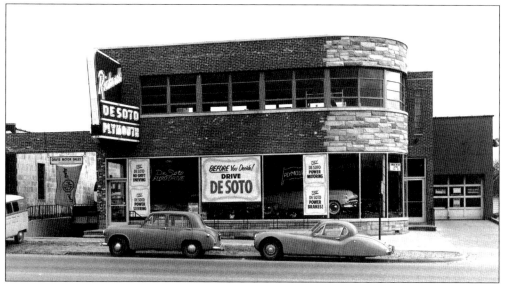

The building at 34 East Michigan Avenue was once a DeSoto dealership. Today it is home to a carpet cleaning business. Soon it will disappear as part of the Water Street Project.

The interurban car barns on Michigan Avenue became a Parker's Outlet store and later a Wrigley store. The building was demolished in 1974.

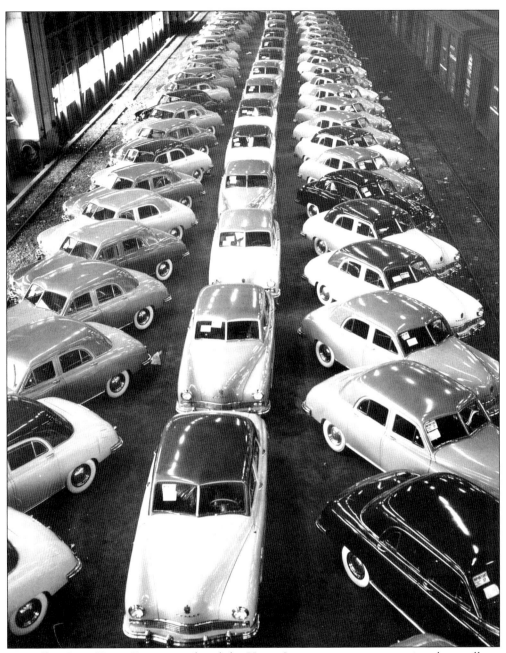

At Willow Run, Kaiser-Frazer introduced the Henry J, an attempt at penetrating the small car market in 1950. The car was overpriced and Kaiser-Frazer was plagued by a reputation for poor quality. Employees at Willow Run began to suspect something was wrong when finished cars were left in the lot for shipping, and were never shipped.

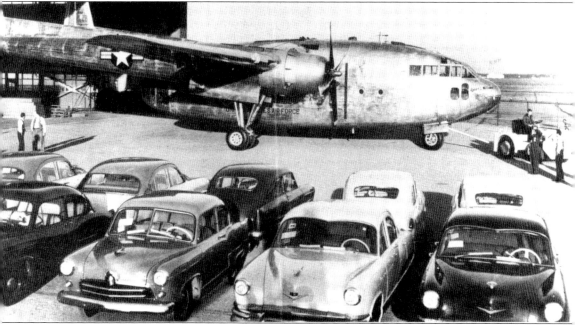

Kaiser-Frazer brought the manufacture of airplanes back to Willow Run in 1952, with the C-119 cargo plane called "The Flying Boxcar." This was an attempt to keep the troubled company from going under, but the concerns over the problem of low quality proved to be a great problem. The Air Force canceled all contracts with the company and, in 1953, that spelled the end of the Kaiser-Frazer years at Willow Run.

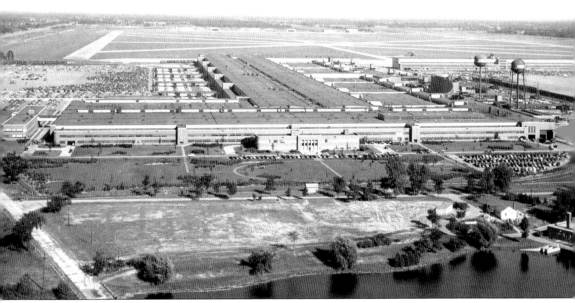

A fire destroyed the General Motors transmission plant in Livonia, and a new plant was needed right away. Willow Run was available and so General Motors quickly settled in. General Motors even used a bulldozer to push the Kaiser-Frazer equipment out the door. General Motors would remain at Willow Run until the early 1990s.

The building on the northwest corner of Michigan and Huron is pictured as it appeared in the 1950s. This was before the addition of aluminum siding gave it the so-called "modern" look. Now some would like to get rid of the modern look and bring back its original charm.

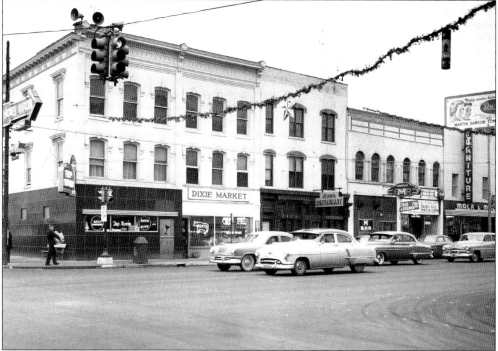

The Tap Room bar has occupied the southwest corner of Michigan and Washington for many years and would continue to do so for many more. All kinds of interesting people have stopped in over the years. It is said that during World War II, comedian Phyllis Diller, then a housewife living on Oakwood, would stop in and tell jokes to the other customers. Her homemaking skills were not envied.

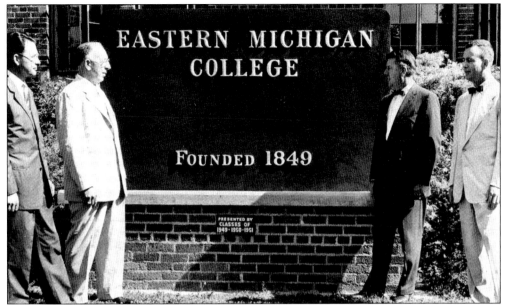

The name of the Michigan State Normal College was changed in 1957 to Eastern Michigan College. Once the name was changed, the signs around the campus had to be changed as well. Pictured at a ceremony marking the changing of the name are, from left to right: Rodney Hutchinson, Mayor of Ypsilanti; Eugene Elliott, President of Eastern; Bruce Nelson, Dean of Instruction; and James Green, Director of College Planning and Development. (Photo courtesy of Eastern Michigan University Archives.)

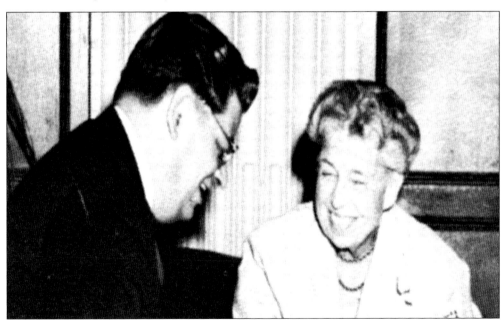

On November 12, 1957, Mrs. Eleanor Roosevelt visited the campus of Eastern Michigan College, as Eastern was then known, and spoke to a standing-room-only audience of students and faculty in Pease Auditorium. She told her audience of her recent visit to the Soviet Union, and held her audience spellbound for over an hour. (Photo courtesy of Eastern Michigan University Archives.)

110

There is more to life than reading and writing. For a full life, one must study the arts, as these young women did at the Michigan State Normal College. (Photo courtesy of Eastern Michigan University Archives.)

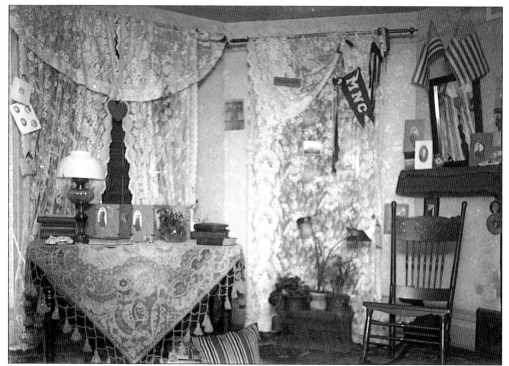

Some things never change, such as the amazing amount of clutter that can accumulate in the room of a college student.

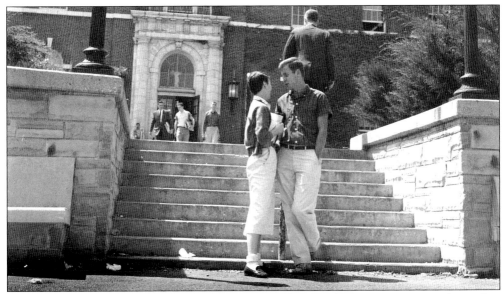

The educational opportunities provided by major colleges and universities are not limited to the classroom. Life on campus gave students the time and place to develop the interpersonal communication skills necessary to achieving success in life. These skills include flirting. (Photo courtesy of Eastern Michigan University Archives.)

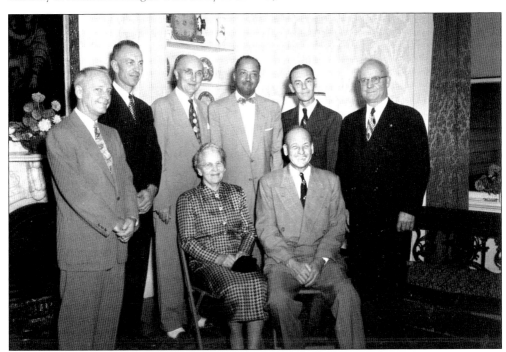

Dr. Lawrence C. Perry (center) was the first African American dentist to open a practice in Ypsilanti. Respected for his skill, his practice crossed racial lines. Dr. Perry was the first African American to win election to the Ypsilanti Board of Education and served four consecutive terms. He received more votes in his last election in 1954 than any other school board candidate. Perry School was named in his honor, after his death.

Seven

THE 1960S, 1970S,
AND BEYOND

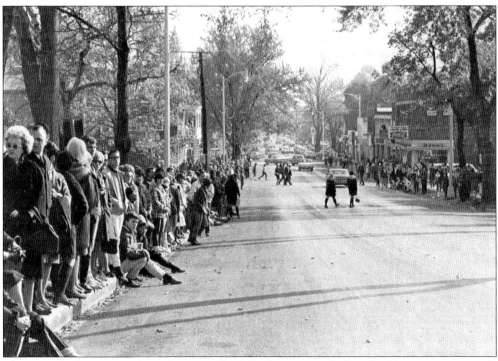

This view looks east on Cross Street in the fall of 1966, just before the Homecoming parade began. The Homecoming parade could attract a crowd, even in the nonconformist 1960s. (Photo courtesy of Eastern Michigan University Archives.)

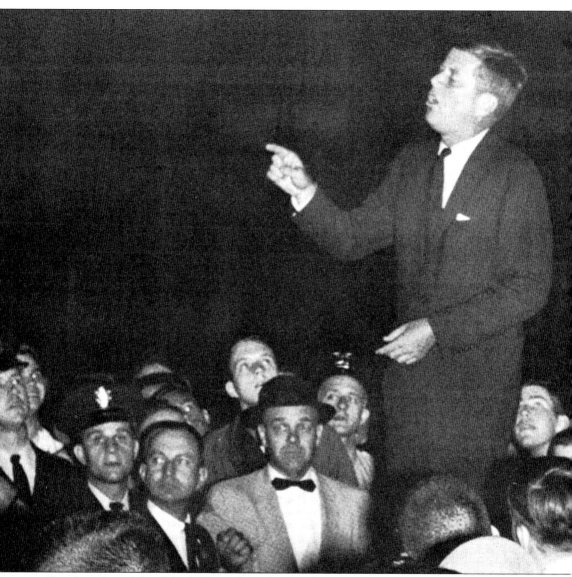

Presidential candidate John F. Kennedy made a brief stop in Ypsilanti on the morning of October 20, 1960. The stop was not planned. Kennedy was riding in his motorcade to Ann Arbor when the mass of students jammed the strreet in front of McKenny Union forced him to stop. He made a two or three minute off the cuff speech, telling the cheering students he stood for the "oldest party in years but the youngest party in ideas." He then asked to be excused because of the late hour (1:15 a.m.), and because he had a difficult schedule planned for the next day. (Photo courtesy of Eastern Michigan University Archives.)

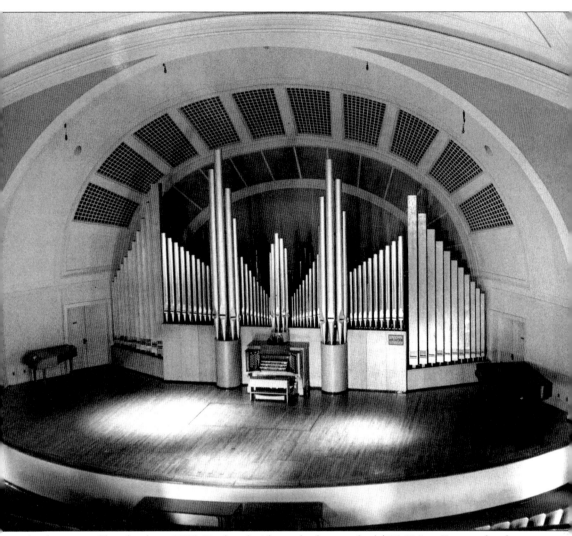

At the time of his death in 1955, Frederick Alexander bequeathed $85,000 to Eastern for the purchase and installation of an organ in Pease Auditorium. The Aeolian Skinner organ was installed by Erich Goldschmidt, who personally voiced over 4,500 pipes. The new organ was dedicated on January 15, 1961. (Photo courtesy of Eastern Michigan University Archives.)

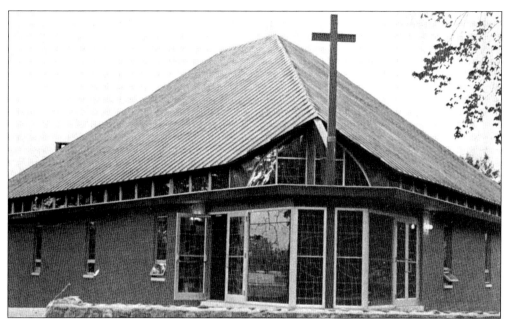

Holy Trinity Student Chapel was dedicated in 1965 to serve the Catholic population of students, faculty, and staff at Eastern Michigan University. When dedicated, it was the first Catholic church in Washtenaw County to conform to the reforms of the Second Vatican Council. (Photo courtesy of Eastern Michigan University Archives.)

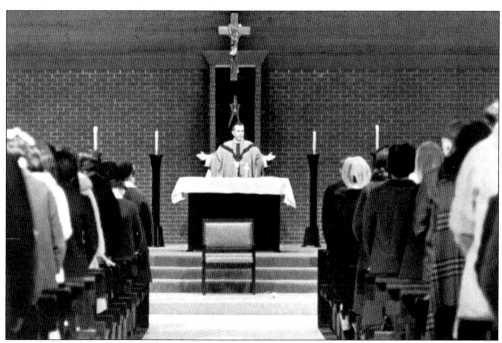

Fr. Leo Broderick was the founding pastor of Holy Trinity Chapel, and is seen here as he says mass at the altar of the new church. Fr. Broderick was surprised one Sunday to see an increase in the number of students at each mass. The students came to hear his sermon, which was on the subject of sex. (Photo courtesy of Eastern Michigan University Archives.)

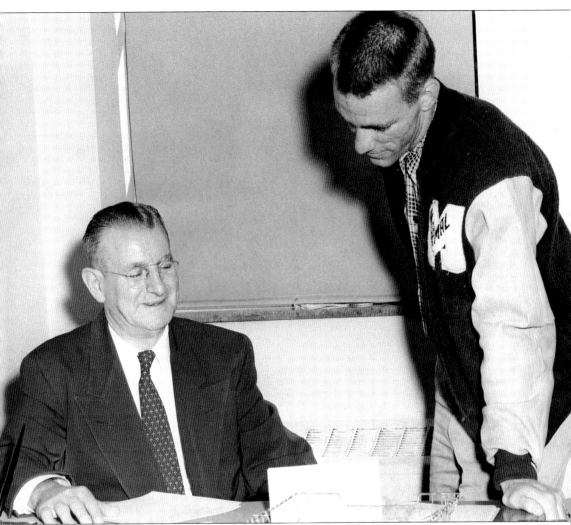

James "Bingo" Brown (1892–1965) said being Dean of Men at the Michigan State Normal College, a post he held 1927 to 1962, was the best job in the world, because he was helping others. As Dean of Men, "Bingo" Brown made a lasting influence, and was most likely the best known and most loved person in the history of EMU. No student was ever too far away for him to reach out and help. He was a friend and wise consular to the students. He was also president of the National Boxing Association in 1932 and 1933. "Bingo" Brown was "the Consummate Gentleman." (Photo courtesy of Eastern Michigan University Archives.)

Demolition of the Normal Gymnasium began on January 21, 1965. Plans to turn the site into a park were never realized, and instead it was made into a parking lot. (Photo courtesy of Eastern Michigan University Archives.)

Harold Sponberg was President of Eastern Michigan University from 1965 to 1974. He oversaw the phenomenal growth of the campus, as more than $54 million in construction projects were completed or started during his tenure. Enrollment at Eastern rose from 10,188 in 1965 to 19,000 in 1974, and the athletic prowess of the university had never been better. As cited by the EMU regents, Sponberg "presided over EMU's role as a precedent-setter in higher education and during EMU's maturity into a multi-purpose University with a national reputation for excellence." (Photo courtesy of Eastern Michigan University Archives.)

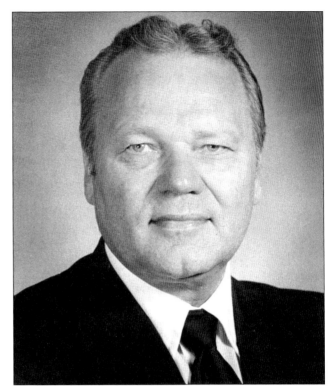

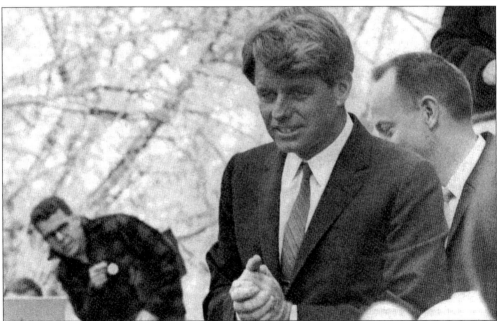

New York Senator Robert Kennedy made a planned visit to the campus of Eastern Michigan University on Saturday, October 29, 1966, as part of an eight-hour visit to Michigan to support Democratic candidates in the upcoming elections. He made a brief speech to an enthusiastic crowd of 3,000 from the steps of Pease Auditorium. (Photo courtesy of Eastern Michigan University Archives.)

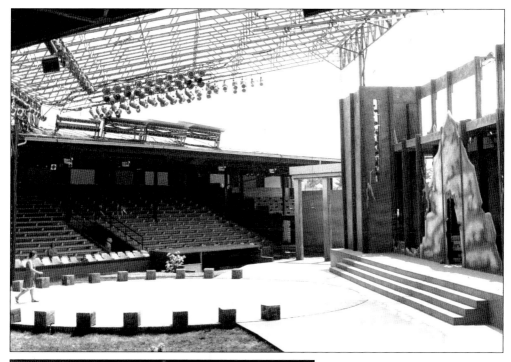

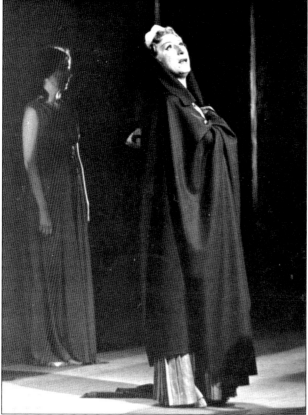

The Greek Theater is one of the great should have beens of Ypsilanti history. The idea was both bold and simple: the world's only English-speaking professional repertory company devoted to Greek drama and comedy, in an American city named for a Greek hero. Planning began in 1963 and became reality on June 28, 1966, when a white-tie audience of 1,900 filled EMU's Briggs baseball stadium to watch the world's first professional English-language performance of Aeschylus' *Oresteia* trilogy.

Dame Judith Anderson, one of the leading actresses of the day, played Clytemnestra in *Oresteia*. One reviewer called her performance "magnificent" and noted that "a few of the Olympian Gods survive and have smiled on Ypsilanti."

Bert Lahr, best remembered as the Cowardly Lion in *The Wizard of Oz*, was warmly greeted upon his arrival at Depot Town. Lahr played the lead role in Aristophanes' *The Birds*. The two plays, *Oresteia* and *The Birds*, were staged on alternate nights for 12 weeks, and nearly 50,000 people came to see the plays.

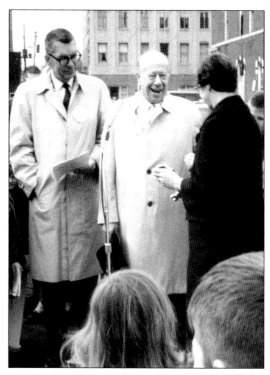

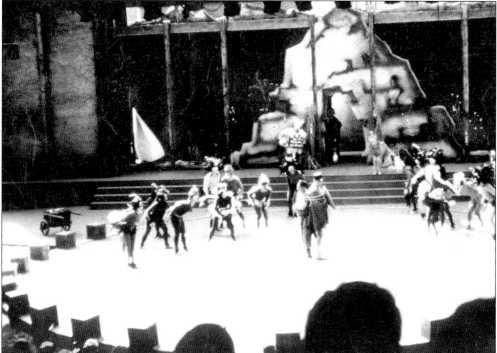

The Greek Theater was successful in every way, except financially. The theater could not raise the funds needed to keep it going. The first season was the last season. Still, it might have been. Briggs Baseball stadium is pictured as it appeared during a performance of *The Birds*.

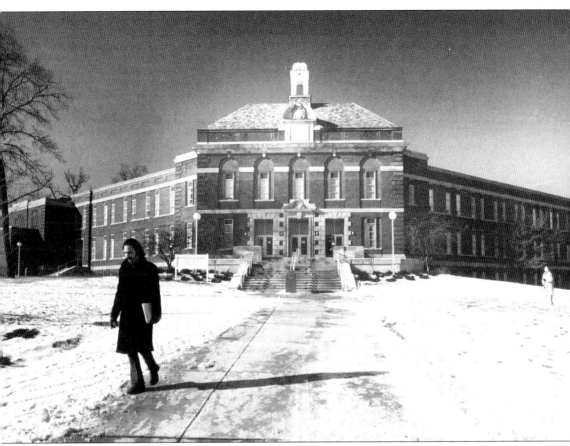

Roosevelt High School was built in the 1920s, as a laboratory school for the training of teachers. In 1968, the Michigan State Legislature decided that Roosevelt was to be phased out as a school by June of 1969, and the space was to be turned over to the university. The mission of the laboratory school as a place to train teachers no longer applied, it was reasoned, because there were now off-campus centers of student teaching. The last graduation ceremony was held for 89 seniors in June of 1969. Today, the building is home to the departments of home economics and military science. (Photo courtesy of Eastern Michigan University Archives.)

For many years, the fortunes of the part of the city now known as Depot Town rose and fell with that of the railroad. As the railroad reached it peak during the years of World War II, so did Depot Town, and as the fortunes of the railroad fell in the years that followed, Depot Town's did too. By the 1960s, Depot Town had become the part of the city no one wanted to talk about. It was the section of the city that parents told their daughters to stay away from. (Photo courtesy of Eastern Michigan University Archives.)

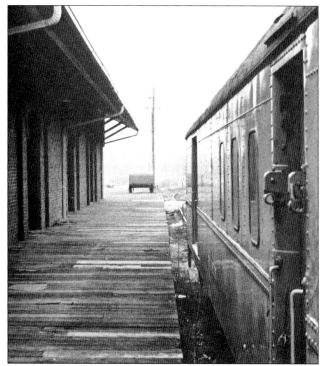

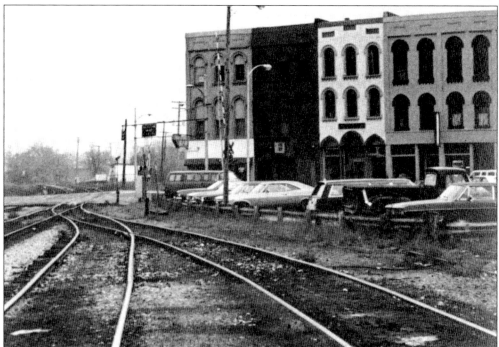

A motorcycle gang had moved into Depot Town, and had made their headquarters in one of the buildings there. The members of the gang hung out in a bar down the street, and, it is said, people risked getting beat up for looking in the window. (Photo courtesy of Eastern Michigan University Archives.)

Then in 1969 someone dropped a stick of dynamite down a chimney in the Follett House, the wrong chimney as it turned out, to scare the gang. The gang defiantly announced that this did not frighten them, and that they were not leaving. The gang then left on a vacation from which they have yet to return. This left the way clear for urban pioneers to move in, determined to turn Depot Town into a source of pride for the city. (Photo courtesy of Eastern Michigan University Archives.)

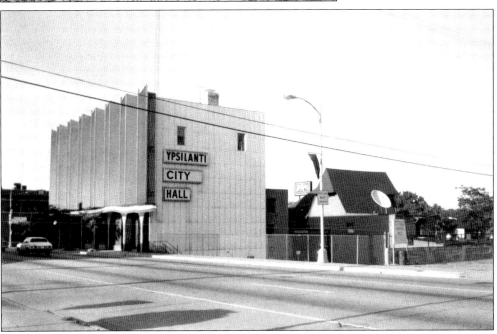

The aluminum siding salesman came to town in the late 1940s and 1950s and convinced the Ypsilanti Savings Bank people their building needed the "modern" look. The building became the Ypsilanti City Hall in 1974, and was later voted the ugliest city hall in the state of Michigan. The siding was removed in the 1990s, and once again the building enjoys some of its old charm.

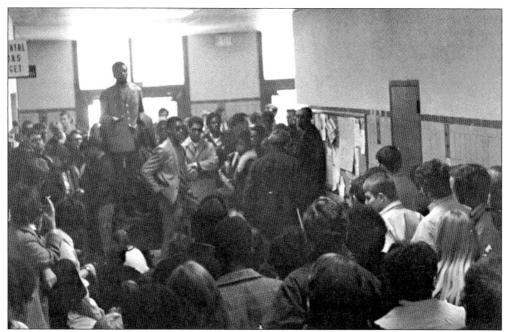

The 1960s was a time of campus unrest, even at Eastern. Issues such as war and peace, poverty, and race became subjects of social concern. On the morning of Thursday, February 20, 1969, students demanded a meeting with President Sponberg, to demand increased involvement of black students in university programs. The students staged a sit-in at Pierce Hall as part of their protest; but left after police made arrests. (Photo courtesy of Eastern Michigan University Archives.)

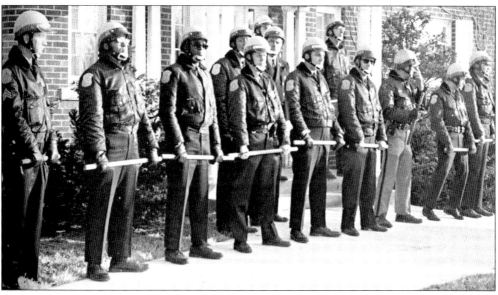

The students then marched on President Sponberg's house where they were met by line of Michigan State Police officers. Similar events were to occur in May of 1970, after President Richard Nixon ordered the "incursion" of US troops into Cambodia. (Photo courtesy of Eastern Michigan University Archives.)

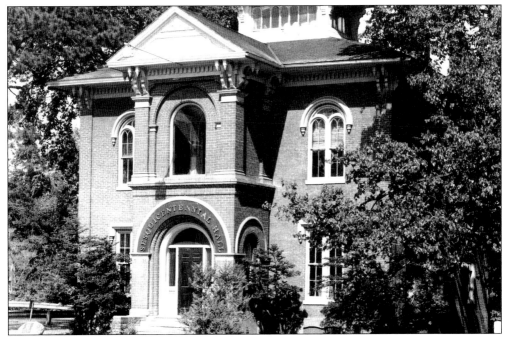

The Ladies' Library Building at 130 North Huron was the Ypsilanti Public Library until 1963, when the library moved to the old post office building on Michigan Avenue. The building stood empty for a time, and was then used as the office of the Greek Theater. Once the Greek Theater failed, the building again stood empty for a time. The house then served as the main office for the office for the Ypsilanti Sesquicentennial, held in 1973. After the event was over, the building once again stood empty for several years. Later, it was converted into office space, but that did not work out. So now, it is once again a private residence, its original use.

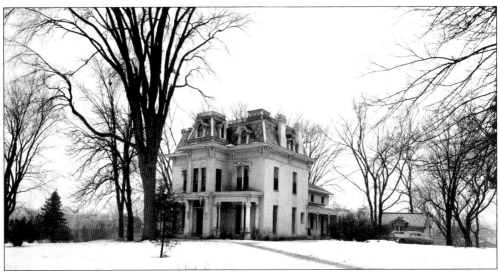

The Gilbert House at 227 North Grove was built in 1860 by John Gilbert. This Second Empire house was purchased by the city in 1932 and used as the Ypsilanti Girls and Boys Club until 1974. Then the house stood empty for several years. It was restored to its former glory in 1987, and now has six beautiful apartments.

Winter in Michigan can be harsh, but there is beauty in the harshness. This undated photograph was taken at 219 South Huron Street.

The new Frederick Alexander Music Building at Eastern was completed in 1980. The building features three large rehearsal rooms for a band, choirs, and an orchestra, a 150-seat recital hall, an organ/teaching/recital facility, and 64 individual practice rooms. The building employed the latest in acoustical and sound isolation techniques. After Ypsilanti grew out of the 19th century and into the 20th, it grew out of the 20th and into the new millennium. The city has faced a number of challenges over the years, but rose to face and overcome each one. It is safe to say, the future of Ypsilanti rests on a firm foundation. (Photo courtesy of Eastern Michigan University Archives.)